IMAGES
of America

WARREN

4/28/10

To Spencer —
Enjoy this look back!
Martha Burczyk

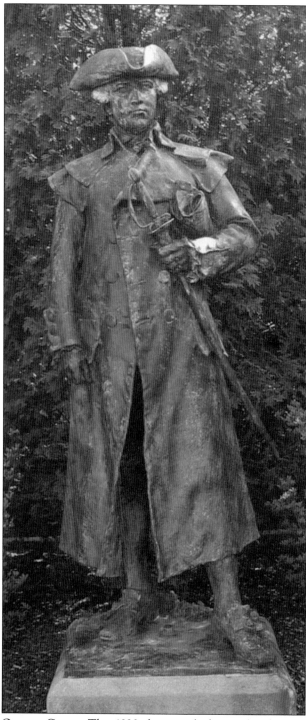

General Joseph Warren (1740–1775) was born in Roxbury, Massachusetts. Warren was a doctor, Harvard graduate (1759), soldier, and patriot. He was appointed major general but fought as a private in the Battle of Bunker Hill, where he was killed in battle. This sculpture stands in his hometown. It was common for townships and villages to be named after great American patriots, but the namesake for Warren, Michigan, was disputed for many years, as there was another with the same name. Rev. Abel Warren ministered to most of the citizens of Warren Township until his death on September 5, 1862. His wife Sarah carried on his work until her death on December 6, 1873. They are buried in St. Clement cemetery in Center Line. Without any hard evidence to the contrary, the city council decided by consensus that the city was most likely named after General Warren. (Photo courtesy of the Warren Civic Center Library.)

ON THE COVER: This 1920 photograph shows a bustling Warren Co-op, housed in what was the Wilson and Son Mill on Chicago Road. Its proximity to the railroad made it the most convenient location for such a venture. The structure itself had a small vestibule added on in later years, and was open for business until it was torn down in 1995. (Warren Historical Society.)

IMAGES
of America

WARREN

Martha Ruth Burczyk

ARCADIA
PUBLISHING

Published by Arcadia Publishing
Charleston SC, Chicago IL, Portsmouth NH, San Francisco CA

Printed in the United States of America

Library of Congress Control Number: 2009925356

For all general information contact Arcadia Publishing at:
Telephone 843-853-2070
Fax 843-853-0044
E-mail sales@arcadiapublishing.com
For customer service and orders:
Toll-Free 1-888-313-2665

Visit us on the Internet at www.arcadiapublishing.com

*To CF who always encouraged me to write, and to Karen,
whose artistic discipline helped inspire me to do it!*

CONTENTS

ACKNOWLEDGMENTS

This project could not have been completed without the tireless support and assistance of everyone at the Warren Historical Society, especially Sue Keffer, Dorothy Cummings, Madeline Zamora, Michele DeDecker, Hubert and Dorothy Leech, Fred Gemmill, and Wesley Arnold. Their generous offer to be available any time was greatly appreciated. As a professional photographer and local historian, Wesley Arnold was a wealth of knowledge and his good-natured assistance and pursuit of accuracy was of enormous value. The people at the Warren–Center Line libraries were also great guides to local resources, especially Cyndi Knecht, Stacey Rottiers, Marjorie Murray, and Anne Cross.

Also thanks to Jim Boufford, the Burton Historical Collection, Jean DeDecker, Dennis Edwards, Mike Grobbel, Danielle Kaltz, Larry Kinsel at General Motors, Diane Steil at Macomb County Community College, Detroit Transit History, the Macomb County Library, the Saarinen Archives at the Cranbrook Institute, Dolores Schulte, Father Bondy at St. Anne Catholic Community, Erick Williamson with the City of Warren, Dr. Roberta Hughes Wright, and two wonderful editors, Anna Wilson and John Pearson. Anna and John, I couldn't have managed this without your expertise and guidance, and yes at times, patience.

Thanks to the encouragement and loyal support of loving friends and family, especially Karen and CF, Marj, father Walter Burczyk, and mother Ruth Burczyk, who is missed every day.

The images in this volume appear courtesy of the following, in alphabetical order, using the parenthetic acronym throughout the book: Albert Kahn Family of Companies, www.albertkahn.com (Albert Kahn Associates Inc.), City of Warren (CW), Detroit Transit History (DTH), Grobbel Family (GF), General Motors Company (GMC), Macomb County Community College (MCCC), Martha R. Burczyk (MRB), St. Anne Catholic Community (SACC), Warren Historical Society (WHS), Warren Public Library (WPL), Wesley E. Arnold (WEA), and Ypsilanti Historical Society (YHS).

Maps can be viewed for reference on pages 20, 21, and 102.

INTRODUCTION

The history of Warren epitomizes the American dream and story. It went from wilderness to the most prosperous town in the United States for a while. History did not start with the white man's arrival, and the presence of Native Americans in the Warren area must be acknowledged, although few traces of them were left. And history also did not begin with man. It is often forgotten that the time that mankind has been here is but a tiny fraction of the time that has passed. After the glaciers melted, forest wilderness evolved into which man migrated. Europeans came here seeking furs, and caused the Native Americans, who had lived here for thousands of years, to fight each other. The French controlled the area from 1701 to 1760, followed by British rule from 1760 to 1815. Both the French and British paid Native Americans a bounty for scalps. Early settlers in Michigan often paid with their lives. The Moravian missionaries from Germany converted some Native Americans to Christian beliefs, and later they laid out and built the first road in Michigan, which went through Warren. The Americans won control, and at last in 1818 the rule by force, which had reigned for eons, was superseded by rule of law. A settler could start a farm without fear that a scalping party would kill him and his entire family.

Land was selling for $1.25 per acre. The Erie Canal had opened in 1825 and settlers were coming in to Detroit in boatloads numbering in the hundreds. Louis Groesbeck was the first recorded settler; he arrived in Warren in 1830. Settlers first made lean-to shelters to protect them from the fierce wolves, cougars, wildcats, and bears, and from smaller troublesome varmints like raccoons, which could destroy a family's supplies in one night. Gradually the land was drained, woods cleared, crops planted, and rough stump farms gave way to regular American farms. In April 1837, a group of farmers met in Warren and elected township officers. The people of Warren and Center Line often had German and Dutch accents because so many had emigrated from Prussia and the Flanders region of Belgium. Roads that were seas of mud in spring and fall were planked. After the planks rotted and became wheel breakers, they were replaced with gravel roads.

Everyone worked to do his or her share, and everyone was held to be responsible for his or her actions. A sense of community developed. Neighbors helped neighbors. When a neighbor got sick it was not uncommon for other neighbors to help. There were ploughing bees, threshing bees, barn, school and church raisings, and picnics. Crime was practically nonexistent. Offenders had to do community work on the roads. No one used locks on their doors. If a farmer needed something they would just come in and take it and would settle up the next working day. There was a standard of community conduct in that everyone was expected to treat others as they would want to be treated. Every child had chores assigned according to their ability. They either learned their lessons and pursued education or were put to work on the farm.

Local industries were started such as carriage shops, blacksmiths, stores, breweries, and of course taverns. Goats and other animals were used to keep grass short. All food was produced locally and lacked preservatives. A need for better community services led to Warren becoming a village in 1893. As the population increased, so did demand for local products. The stagecoach was replaced

with a horse-drawn railroad car; the steam engine was the next upgrade for transportation and farm equipment in the 1860s. Later, the electric revolution led to electric lights and appliances in homes in 1913, and electric trolleys.

Warren probably would have remained rural with a population of around the 1930 numbers of 2,600 if war had not broken out. World War II transformed Warren, and Warren learned early that freedom was not free. Citizens made many sacrifices, including their lives. The huge Arsenal of Democracy was planted in the middle of Warren, bringing with it practically overnight thousands of people who needed housing, transportation, water, infrastructure improvements, and material goods. The population jumped from 2,600 to 43,000. The people needed a better form of government and voted to become a chartered township. Not long after that, it became a full-fledged city that was home to the Technical Center for the biggest corporation in America: General Motors, which had over 20,000 employees. For a short time, Warren became the fastest-growing and richest community in the United States, thanks to the many automotive suppliers who located there and the many employees who wanted to live closer to their workplaces.

Parents were busy creating a better life for themselves and their children. Businesses, particularly utilities and banks, served the people, not the other way around. The generation that grew up in the Great Depression and fought in World War II created and sustained the greatest period of prosperity this country has ever known. Warren was a leader in this, yet Warren has not forgotten how it happened. In its new Veterans Park and during events at its new civic center, veterans have been personally honored, and an army general spoke to the public to warn us again that freedom isn't free and that we must always be vigilant and be prepared.

I am a longtime historian in Warren–Center Line and was very much impressed when author Martha Burczyk came to our research center asking questions and digging into our files. She has been thorough in her research and has uncovered many historical details that had not been the prevailing knowledge. She scoured other sources and libraries and has included her findings in this book. She had to work with varying accounts on questions such as "Beebe's Corners" and has shed new light on our history. As we have spent years rebuilding a historical photo collection destroyed years ago, Martha has effectively told the story of Warren's development. She has provided a valuable resource, long overdue. I am proud of the work she has done.

Wesley Arnold, Historian
October 2009

One

SETTLERS

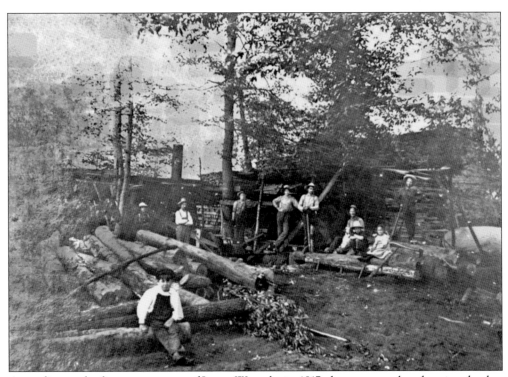

According to the first survey notes of James Wampler in 1817, the area was abundant in ash, elm, birch, and maple trees. The invention of the steam engine helped the labor effort, shown here with this group of loggers in winter at the Jennings barn, no doubt working long, hard days in bitter weather. Accomplishing the clearing and construction of shelter involved the entire family and community, with women cooking and children helping wherever they could. (WHS)

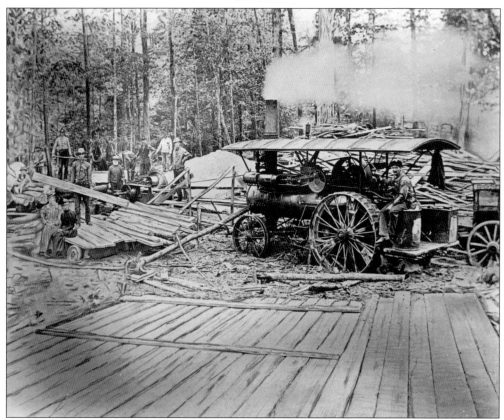

There was considerable clearing to be done in the dense, marshy land northeast of Detroit. Logging was a community effort, as shown here around the 1870s. Note the foreground, which shows a cabin in progress with the door framed out. This type of one-room cabin was strictly utilitarian, to serve as basic shelter from the elements. There are variations on this type of construction depending on the culture and background of the builder, but this one is identical to the one shown behind John and Fredericka Minda on the next page. (WHS)

John and Fredericka Minda stand in front of their cabin in 1927, celebrating 63 years of marriage. They married in 1864 in Germany; their anniversary announcement in a local paper stated that they came to the area in 1865. They had a 50-acre farm on the south side of Nine Mile Road, just east of Ryan Road. Another cabin, like the one shown here, was owned by the Dunbar family. Dunbar Cabin was moved, reconstructed in Eckstein Park, and stood for several years until it and the train depot were destroyed by vandals in the 1960s. (WHS)

Frank J. Licht, who had many roles in the early development of the village, is shown here working the land. He was also a tinsmith, village lamplighter, and letter carrier, and was active in the business of the town. Licht was born in 1885 in Royal Oak, where he also had served as mail carrier. He later moved to Warren, where he married Margaret Flynn in 1908. They had two children, Eunice and Robert. The purpose of the leather strips, or fringe, shown here on the horse tack is to keep flies away. (WHS)

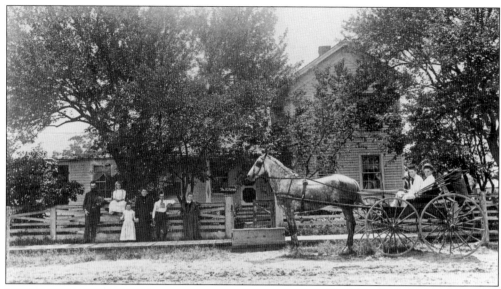

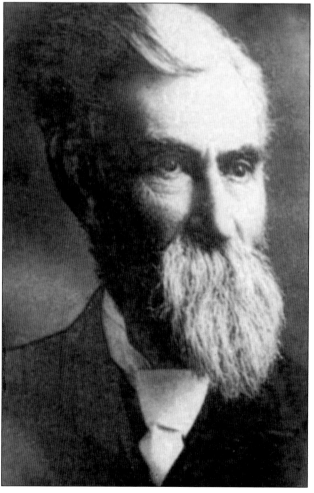

Dr. John C. Flynn was born in New York City in 1850. He grew up in Lawrence, Massachusetts, and completed medical training in South Bend, Indiana. John and his wife Anne (Jones) of Toledo arrived in Warren in 1880, where he was the first doctor to set up a practice covering much of the township. Shown above in front of their home on 6048 Chicago Road are, from left to right, John Flynn, daughters Carrie (on fence) and Margaret, Anne Flynn, nephew Arthur Jones, and Ellen Hannah of Toledo, who lived with the Flynns. Sons Bob and Warren are seated in the wagon. Flynn also served as the first village president, and upon his death in 1910, Anne moved in with daughter Margaret and her husband Frank Licht. The house was built in 1865 and still stands today. (WHS)

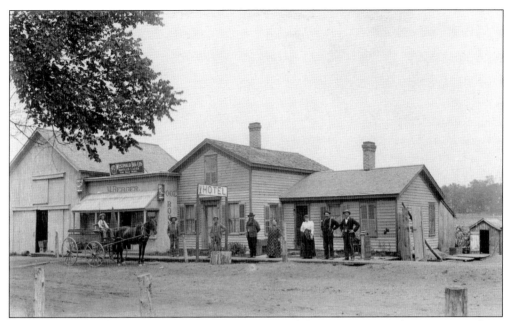

These are the very beginnings of the northwest corner of the Main Street and Davy Avenue (now Mound and Chicago Roads) intersection. On the right is the first hotel on Art Bielman's property that grew to become the Warren Hotel. On the left is the property of Mathias Berger and his wife, who ran a public house where sources say the first township meeting was held. Something must have happened, because members vowed "never to mix [an ale house] with township business in the future." The Hoard residence on Mound Road hosted the very first village meeting; subsequent meetings were held in the homes of other residents until a village hall was erected decades later. The date of this picture is *c.* 1870. (WHS)

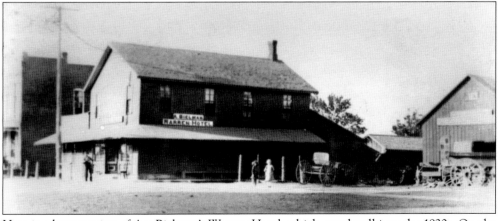

Here is a later version of Art Bielman's Warren Hotel, which stood well into the 1920s. On the right of the photograph is Fred Lutz's wagon shop; on the left is the Berger establishment and residence. (WHS)

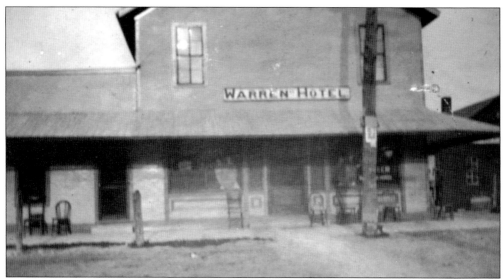

This close-up view of the Warren Hotel shows a bit more detail with chairs, a store, hitching posts, and the pole for electrical service. Fred Lutz's shop is to the right. Beebe's Corners is first identified on Gerald Neil's 1837 map study, which is detailed on page 20 later in this chapter. Prior to this time, there was no official road connecting the northern part of the township with the southern part. The Old Moravian Trail/Territorial Road was the only road from Detroit that passed through Hickory township at that time. It ran through the eastern part of the township toward the Moravian village on the Clinton River. (WHS)

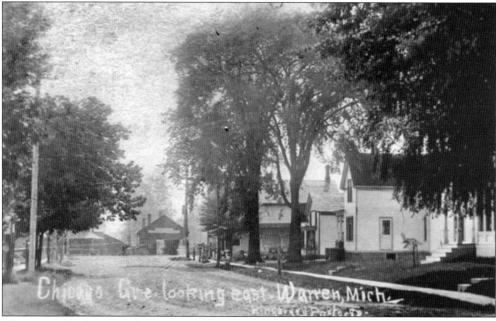

The view of the hotel and Lutz's is seen again when looking east on Chicago Road as shown here. On the right is Charles F. Peck's property at the corner, with the Charles Moore, Cartwright, and Miller homes respectively. (WHS)

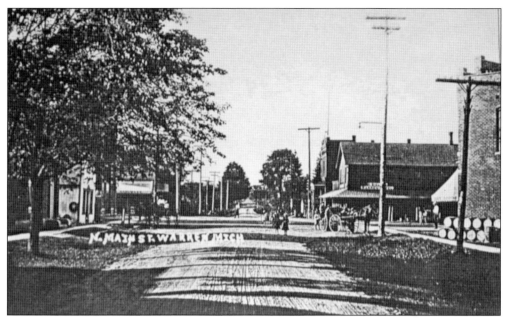

This early view of the village of Warren, looking north along what later became Mound Road, shows Bielman's Hotel on the right, and Murthum's dry goods store in the right foreground. The awning on the northwest corner of Chicago Road would be Rivard's Hardware. (WHS)

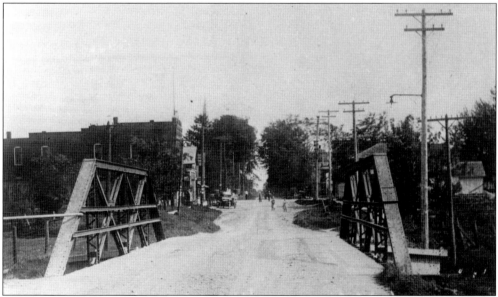

Looking south on Mound Road just before crossing the Red Run Creek in the early 1900s, this is what travelers would see on a trip to Detroit, before entering the village of Warren. To pass into and out of the village, one had to pass through a tollgate run by John L. Beebe, giving Warren an earlier name of "Beebe's Corners" in the 1850s. The Peck store is just visible on the right; on the left are Matt Berger's establishment and the Warren Hotel. St. Paul Evangelical church would be farther south on the left. Atlas maps from the 19th century also show a Beebe's Corners in Richmond Township, where there were many lots owned by Beebe families. As of now they are still considered unrelated to John L. Beebe of Warren. (WHS)

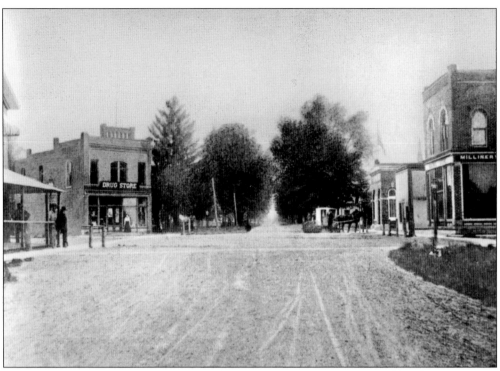

Here is a view of the village looking south on Main Street, as if having just passed over the bridge shown previously. On the right is a closer look at Peck's store, the post office, and the first bank. On the left side are the Warren Hotel and the Murthum dry goods store across Chicago Road. Farther down on the same side of the street would be St. Paul church, shown below. (WHS)

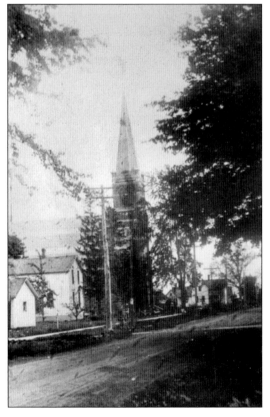

This photograph shows the east side of Main Street (now Mound Road) looking south, with St. Paul church. An early atlas map shows the property to the left of the church as belonging to a Mrs. Walker. This and the old interior shown later are the only known remaining photographs of these views. (WHS)

Village wagon makers shown in this 1900 photograph by John Rinke are, from left to right, George, Charlie, and Carl Gerlach, John Abey, and Julius Steffens. George Gerlach would serve on the council of St. Paul Evangelical Church in 1918, along with Rev. Ernest Schmidt as chairman of the council. (WHS)

This unidentified group gathered for a picture in front of Buechel's store on Van Dyke Avenue north of Ten Mile Road. Buechel's was one of the earliest establishments in the township, originally located at Ten Mile and State Roads, now Sherwood Avenue. The first development in the Center Line area occurred at Ten Mile and State Roads, which was known as Kunrod's Corners in the early 1800s. It is thought that Buechel's original store was earlier owned by a Mr. Kunrod and was the main stop for people trying to make their way to Detroit on rough roads (see maps on page 20). In the late 1850s, John Buechel moved his store to Van Dyke Avenue to be near the recently-built St. Clement Church, visible in the background. (WHS)

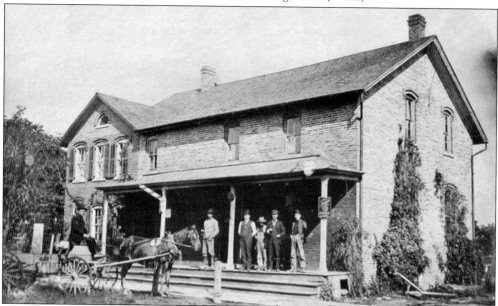

This is the Mathias and Elizabeth Miller homestead, c. 1900, on Van Dyke Avenue near present-day Harding Street. The Millers operated a saloon on their premises and the sign on the porch support advertises Tivoli Beer. The Tivoli Brewery was founded in 1898 in Detroit and later produced Altes beer. The striped arm on one of the porch supports indicates a public stop of some kind, either a place to drop the mail or possibly an early barbershop. (WEA)

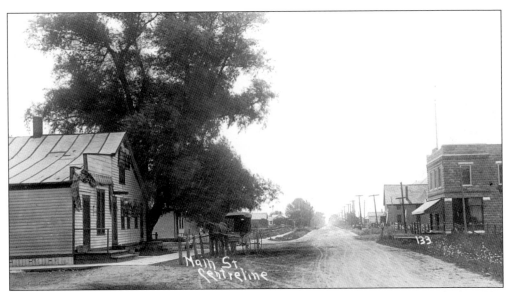

The photographer captioned this *c.* 1914 image "Main St. Centreline." The view is south along Van Dyke Avenue from present-day Ritter Avenue. St. Clement Catholic Church and Buechel's General Store would have been behind the photographer's left shoulder. State Road became known as Sherwood Avenue and angled into Mound Road at Eleven Mile Road as it headed toward Warren Village. An 1839 map study shows the Moravian Trail coming in from the Huron (Clinton) River to the Red Run Creek and down what is now Van Dyke Avenue to Detroit. The intersection at Eight Mile Road (also called Baseline or Territorial Road) was called Dalton's Corners after Michael Dalton. (WEA)

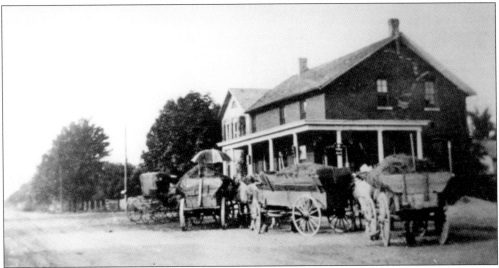

Looking north on Van Dyke Avenue at Harding Street *c.* 1900, this view of hay wagons at the Miller place is one of the oldest known photographs in Center Line. St. Clement church would be behind the photographer. This is the area that came to be known as Center Line, so named because it was on the old "center line" trail that headed north from Detroit, bisecting the "V" formed by the Saginaw Trail (Woodward) and the Huron Trail (Jefferson). Before Warren Township was officially named in 1837, it had been named Aba, and later, Hickory. Warren Village at Mound and Chicago Roads also used Aba as its name, as evidenced by an 1859 atlas. Old packaging from businesses in the area indicate that the community was even called Warren City by some. (WEA)

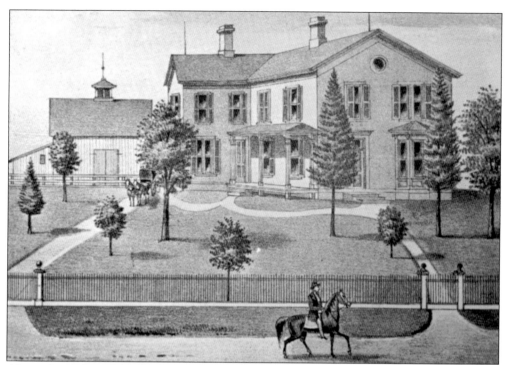

Above, the residence of William C. Groesbeck, brother of Louis Groesbeck, is shown in an appendix to an 1875 atlas map of the township. Louis is credited with holding firm in his successful attempt to correct an error of 5 square miles of the southeastern part of the township had been given erroneously by the state to its neighbor to the east, Orange Township. By 1837 the lost area was retrieved and the township was called Hickory, the next year Aba, and the year after that, Warren. (WHS)

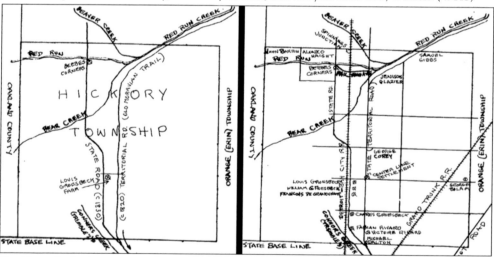

Unable to find adequate visuals to accompany early written histories, Warren civic leader and historian Gerald Neil decided to publish a small book of map studies. At left, the 1837 map shows a line connecting the two State Roads, but there is no street name given to it. This is where Ten Mile Road was established. Kunrod's Corners may have been considered the area that connected the two State Roads, but concrete evidence is not available. At right, the 1839 diagram indicates activity around the township mentioned throughout this chapter. (WPL)

Two

EARLY DEVELOPMENT

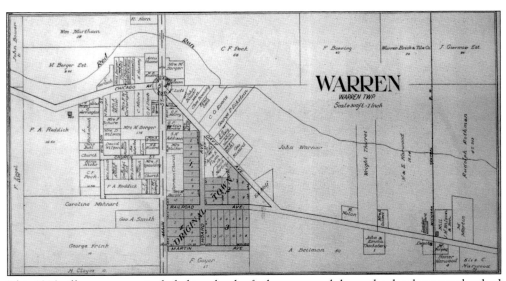

This 1916 village map was included in a book of atlas maps and shows the development that had occurred by the early 20th century. Most of what is shown here is the historic district today. Union cemetery is included in the district, but is about one-half mile west of this map. Davy Avenue was named after Charles Davy, who owned most of the land north of the Avenue at that time. The avenue was later renamed and used as a continuation of Chicago Road. (WHS)

This is a view from around 1900 of the northwest corner of Chicago Road looking west from Main Street, now Mound Road. From right to left are Rivard Hardware, Herb Hoxsey's house, Kennelly house and shoe store, the hall for the International Fraternal Order of the Knights of Pythias, the Chipchase House, and Tharrett House. (WHS)

A small collection of goods might have been stacked outside the store on a nice day. Items such as soap, tools, small hardware, and pickles from the pickle barrel might be among the various sundries offered. (WEA)

Mrs. Wilhemina (Minnie) Murthum, wife of William, stands in front of their store at Davy Avenue (later Chicago Road) and Main Street (later Mound Road) around 1915. With the Warren Hotel on the east and Rivard Hardware and the Peck store on the west, this important intersection anchored early business in Warren. (WHS)

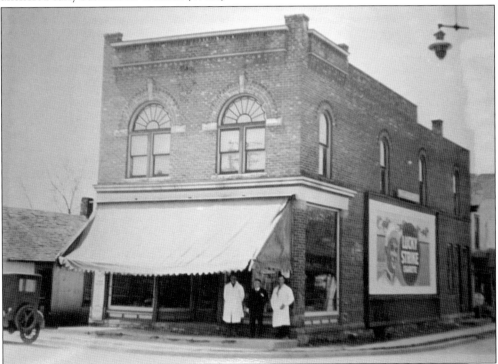

Frank Peck's Grocery and Meat Market at Chicago and Mound Roads offered early villagers the latest in shopping conveniences. Like most general stores at that time, one could buy groceries, meats, and dry goods. Frank's daughter Marion married Norman Halmich, and the couple eventually took over the store. When Mound Road was widened in 1929, a new structure was built. Today, the family name is visible in stone on the façade. The post office at that time is to the left of the Peck store. (WHS)

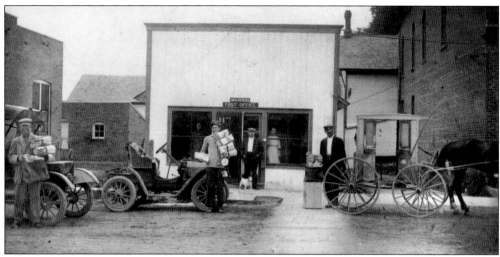

This United States Post Office site, pictured around 1910, was between Peck's store and the First Savings Bank on Main Street in the Village of Warren. By 1905 there were more than 70,000 post office buildings in the country, the largest number to date. However, because of the rural character in Warren, a town post office was not built until much later in the 20th century, and urban development itself took longer than surrounding areas. George W. Corey was the first postmaster in the township, from 1840 to 1858. Fred Lutz was postmaster from 1920 to 1935, when the mail was delivered to Rivard Hardware. (WHS)

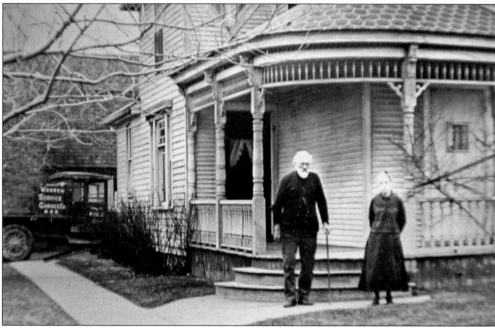

The Victorian-style William Murthum house was built in 1895. It stands today at 5820 Murthum Street, which was named after him. The house was moved 200 feet west when Mound Road changed from a horse-and-buggy dirt road to a paved road in the latter part of the 1920s. Several acres of land were used to build Murthum School, and in the 1940s, Victory School was built next to it. (See page 96.) The truck in the background is from the newly expanded Warren Service Garage (See page 51.) (WHS)

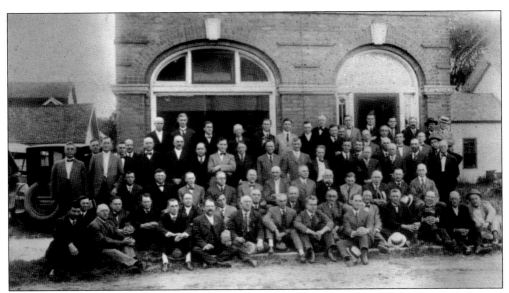

The First Savings Bank was on the west side of Main Street and south of the Frank Peck store and the first post office. It was organized in 1902 as a private bank by Charles A. Burr (at left with bow tie), who served as president, and Arthur Newberry. It became a state savings bank in 1908, with capital stock of $20,000. The bank expanded and moved to Charles Burr's property in 1926 where the Warren Hotel used to be. This photograph was taken around 1915. (WHS)

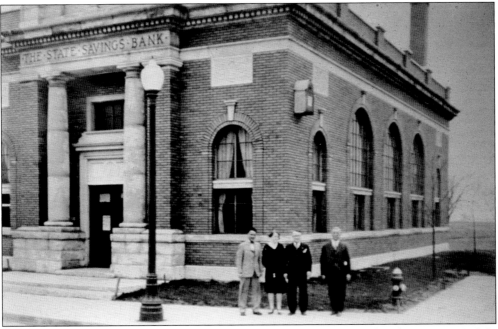

Although this photograph is undated, the new State Savings Bank opened for business in 1926. In front of the new structure, from left to right, are Herbert Schmidt, Erma Hartsig Cromie, Fred Cromie, and Charles Burr. The local *Pageant of Progress* edition of Nellis Newspapers covered the opening of the bank and identified the directors at this time as Charles Burr (president), Jacob F. Hartsig (vice president), Fred Cromie (cashier), C. F. Peck, William L. Hartsig, Louis Busch, Michael Smith, and Edgar Rinke. I. M. Cromie was assistant cashier and Herbert Schmidt was bookkeeper. (WHS)

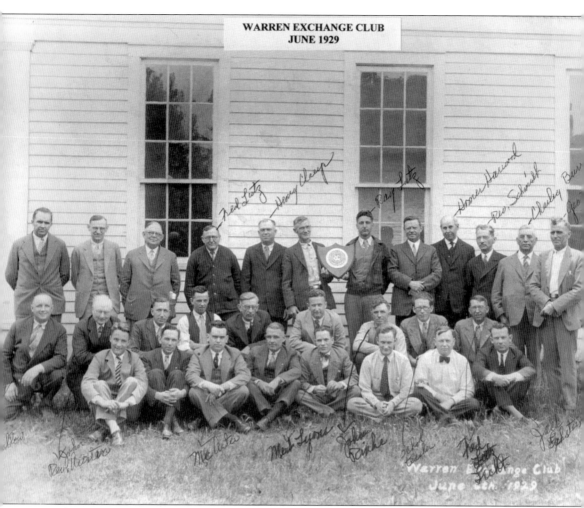

The Warren Exchange Club members, pictured here in 1929 in front of the Methodist Church on Seventh Street, included most of the people that lived and had an interest in the village. Those identified are (first row) a Mr. McArter (third from left), Myrton Lyons (fifth from left), and Jack Eckstein (at far right); (second row) Fred Warblow (left), Rev. John Austin (second from left), and at the right end of that row are Frank Licht, a village school teacher, and John Rinke; (third row) from left to right, Fred Lutz, Henry Claeys, Fred's son Ray Lutz, Homer Harwood, Reverend Schmidt, Charles Burr, and George Eckstein. (WHS)

This newspaper picture is the only known photograph of Anna Bull Zorn (1882–1965) as a young woman. She was married to Christian Zorn; they lived in the house shown below at 31715 Seventh Street in 1935, when she donated the front parlor for one year for use as a library. According to an article in the *Warren Weekly* on May 6, 1981, Zorn had previously met with Earl Stien and Chris Foss, Mrs. Robert Parnott, and Miss Nellie Elkins to form the Warren Community Library. Even in the midst of the Great Depression, the group solicited enough memberships at 25¢ each to have accomplished the creation of the community's first library. The library opened with a collection of 716 donated books. The Zorns are buried in Union Cemetery. Len and Linda Trzaskoma bought and restored the Zorn (originally Joiner) home and restored it for the country's bicentennial celebration in 1976. (WHS)

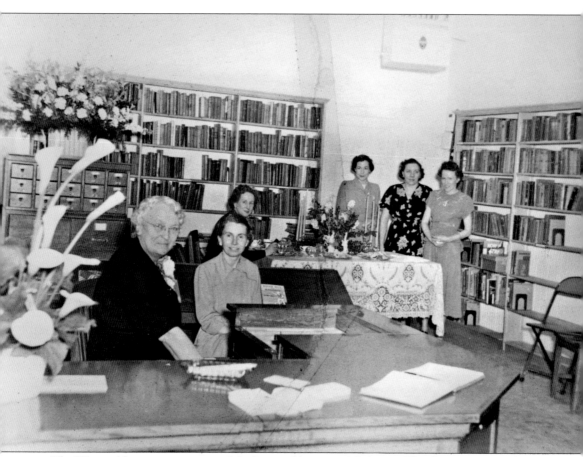

The Warren library system is one of the best and largest in Michigan. The above picture, taken in 1950, shows, from left to right, Anna Zorn, Frank Licht's daughter Eunice Holmes, Hilda McArter, Florence Schmidt, Alma Geisler, and Dorothy Busch. The reception table, flower bouquets, and Mrs. Zorn's corsage seem to indicate a library-related occasion. The library moved to Oddfellows (or Lodge) Hall just west of Mound Road, then next to Village Hall on Beebe Street, eventually becoming the Arthur Miller branch on Thirteen Mile Road. (WHS)

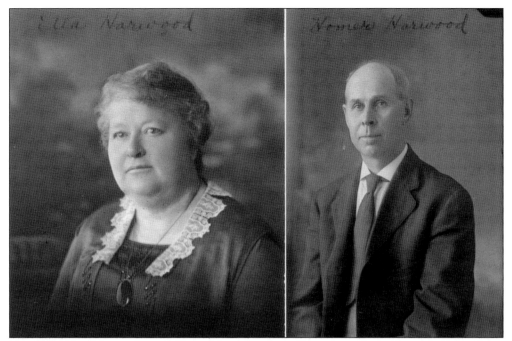

Homer and Etta Harwood were pillars of the community. Homer owned a lumber company and was active in civic activities. Etta was a member of Maccabees, a religious group at the Methodist church. The Harwoods owned a large area of land north of Chicago Road at the railroad. (WHS)

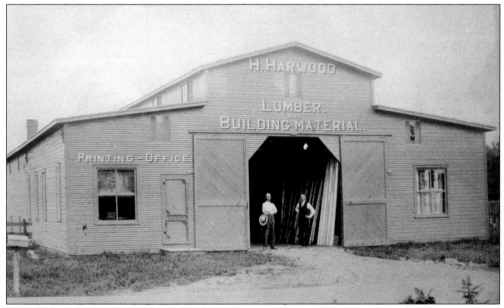

Homer Harwood operated a lumberyard at the most convenient location for loading and unloading train cars—just north of Chicago Road directly west of the railroad tracks. East of the tracks was the Wilson Mill and north of Harwood's property was the Warren Brick and Tile Company. Here, the left wing of the building was a printing office where Harwood published early copies of the *Warren Watchman*. It is believed that A. V. Church Lumber took over this site after Harwood sold it. (WHS)

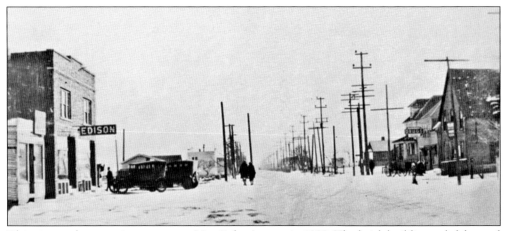

This picture shows a winter scene on Van Dyke Avenue in 1922. The brick building at left housed the Edison office and Ben Wolf's Hardware. The drug store across Van Dyke Avenue was owned by Bradt and Van Valkenbergh and occupied the adjacent house. Valkenbergh served Center Line as postmaster from 1923 to 1927. LeRoy's Blacksmith Shop is the dark building in front of the drug store. The loop for the electric car line to downtown Detroit is covered in snow just to the left of the women. The map on page 102 shows this loop at Ten Mile Road and Van Dyke Avenue. (WEA)

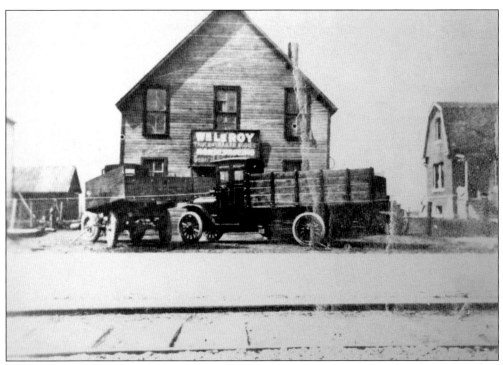

William LeRoy's business advertised horseshoeing alongside the sale of truck and trailer bodies. This was a transitional time from horses to cars as the primary mode of transport in America and in Warren, but both were needed for the farmer well into the 20th century. (WEA)

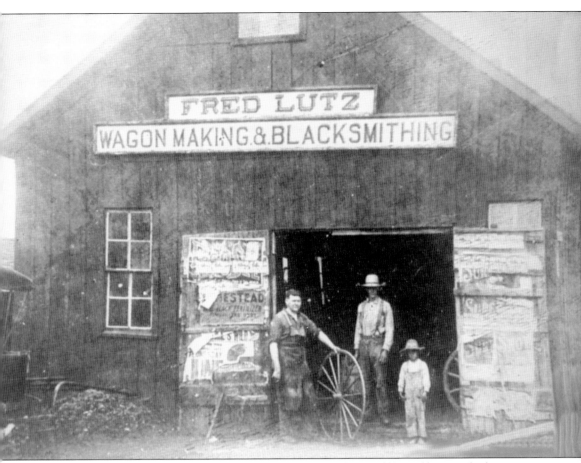

Fred Lutz Wagon Making and Blacksmithing shows Fred working at left, and his sons looking on. Fred opened for business around 1860 next to the Warren Hotel. The shop faced Chicago Road and because the street angles to the east at more than 90 degrees, it was visible from Main Street. Fred never locked his doors on the weekend. He would leave them open in case farmers needed something, and they would settle up with Fred on the next business day. (WHS)

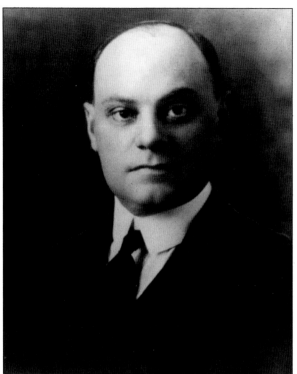

Alexander Joseph Groesbeck (1873–1953) served as the 30th governor of Michigan from 1921 to 1926. A Republican known as "the Road Builder," he promoted the use of concrete to "take Michigan out of the mud," sanctioned prison reform, and restructured and consolidated state government. His father Louis Groesbeck Jr. was township clerk and justice of the peace before becoming Macomb County sheriff. His grandfather, Louis Groesbeck Sr., was the first township president and held many a town meeting in his home. (WHS)

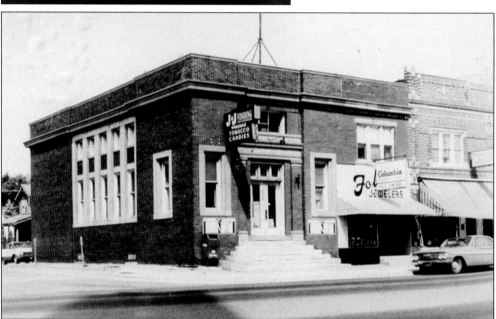

The Center Line State Savings Bank building was opened in November 1920 at Wiegand and Van Dyke Avenues. After the bank failed during the Great Depression, the building housed the Michigan State Police. Then, as shown here, J&J Vending occupied the building in the mid-20th century. Ed Jenuwine owned J&J and had a warehouse elsewhere, and had the concession at the Liberty Theatre. John McGlen owned the Liberty Sweet Shop. Eventually the men swapped businesses. Kids at that time would remember the candy store as a favorite destination. (WEA)

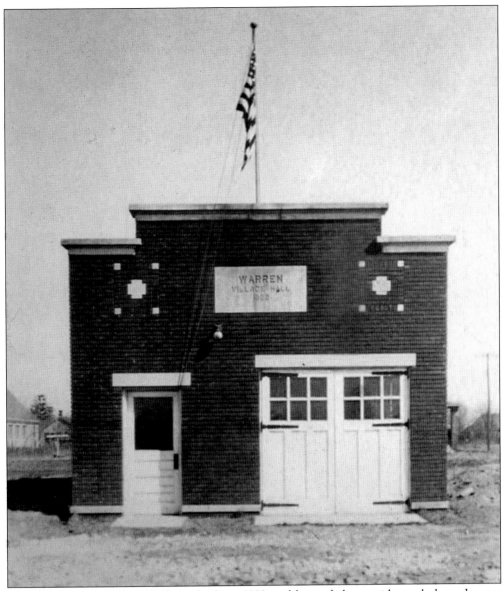

The first Warren Village Hall was built in 1922 and housed the president, clerk, and water department. Early village meetings were held in private homes at the time. The hall is on the north side of Beebe Street and is still used for selected events and Village Historical Commission meetings. (WHS)

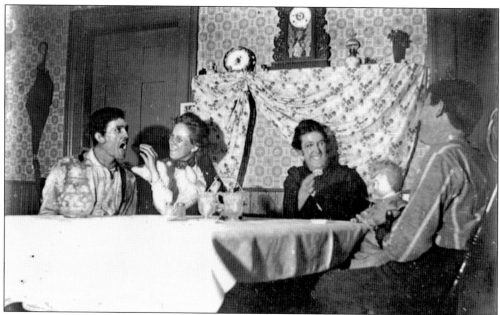

Unlike many photograph subjects of this time, this family sure liked to ham it up for camera. The family did well for that time, as displayed by various wallpapers and fabrics, mantel clocks, glassware on the table, and clothing. These are good examples of interiors from the late 1880s to the early 1900s. The theme of the above photograph seems to be the women pampering or "babying" their men. The woman on the right is playfully offering a pacifier to the man holding a doll, and the woman on the left is feeding her man. The photograph below shows another interior space with yet another comical scene. Family members are not trying too hard to stay out of view from the couple on the sofa, who probably want to be alone, and someone stands ready to cool down the scene. Lace curtains were popular during this time and were signs of their owner's affinity for fine things, and the ability to acquire them. Being able to cover furniture with finely printed fabrics and accessories also offers a clue to this family's abundance of the day. Note the gas lamp on the wall. (WEA)

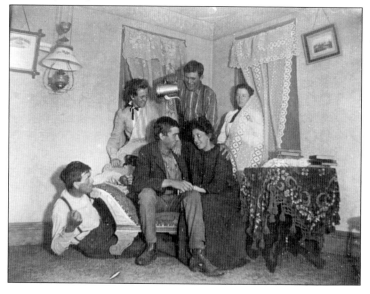

Three

AGRICULTURE

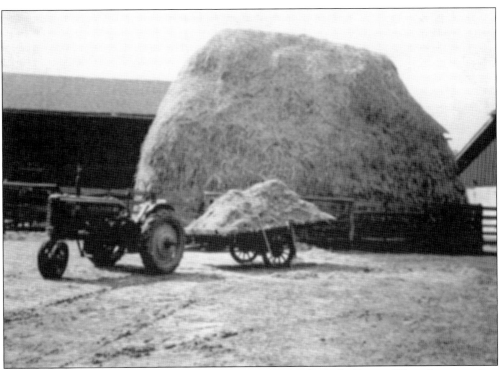

This October 14, 1945 photograph shows a large straw stack on the Bunert-Weier farm two days after threshing. Women on the farm were very much a part of the everyday operation, providing the meals for a hungry team of threshers. Some even had separate kitchens for the occasion. Farming was still very much a part of life in Warren into the 1950s. (WHS)

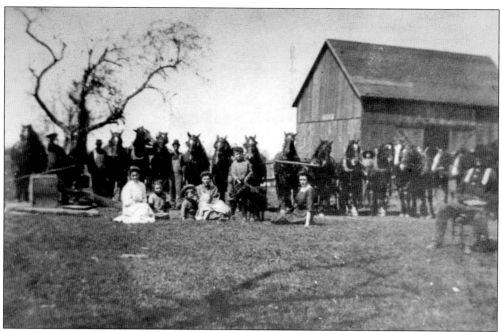

Common events in farming were threshing days and plowing bees. Large farms required many farmhands; farmers helped each other, especially on larger jobs. This help was of immeasurable value if someone fell ill or was unable to carry out their normal jobs around the farm. This was the Grimm barn just south of Eight Mile; on top of the photograph was written, "Plowing bee to help an ill neighbor, 1913." (WHS)

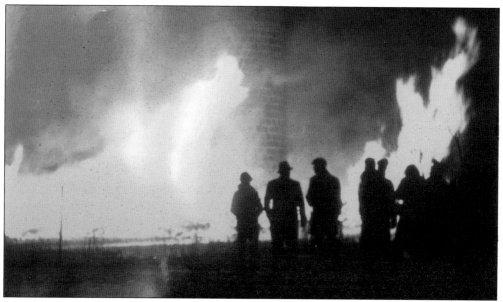

Bringing in a harvest or just looking out for one's neighbors was a mainstay of early development in America and helped to define the meaning of community. This barn fire raged in the middle of the night at Ten Mile Road, but for all its ferocity, no injuries were reported. (WEA)

DR. WM. C. WEICHT'S

SPECIFIC FOR POLL EVIL AND FISTULA

Warranted to cure in every instance, if used according to directions, or the money refunded. It leaves no Stiff Neck after Poll Evil.

DIRECTIONS.—Give about as much as will lay on a silver three cent piece at a dose,—dry on the tongue,—every morning, of No. 1,—every evening of No. 2.

Should the sore discharge too freely, after using the medicine, omit No. 1 for a day or two. This, however, is seldom necessary. Should a Stiff Neck remain after the sore is healed in Poll Evil, continue the medicine. Three packages will cure the most obstinate case. One is sufficient ordinarily.

PREPARED ONLY BY
Dr. WM. C. WEICHT, ANGOLA, IND.
None Genuine without this Signature.

This was a page in the diary of Daniel Stewart, a farmer in Center Line. Based in Angola, Indiana, Dr. Weicht was a veterinarian known in the region for his medicinal remedies, as presented here in a local advertisement selling a cure for equine afflictions around 1880. Fistulas are internal complications that can develop after an injury or infection, while poll evil is an abscess that can form in the sinus area of a horse. The dosing instructions are to put "about as much as will lay on a silver three-cent piece." Millions of 3¢ pieces were minted in silver and nickel from 1851 to 1889. (WEA)

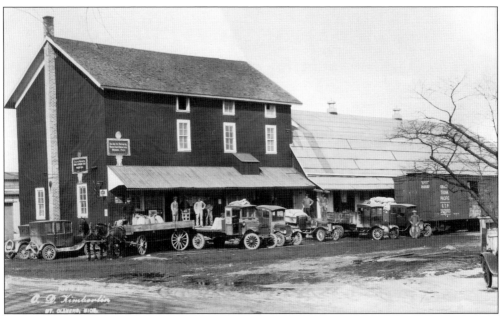

This 1920 photograph shows a bustling Warren Co-op, housed in what was the Wilson & Son Mill on Chicago Road east of the railroad tracks. This flour mill was originally just the large central building established in 1895. The co-op board in 1928 was made up of Louis Busch (president), Ed J. Schoenherr (vice president), Fred Schuster, Henry Halmich, and Joseph C. Murphy. John Rinke was president from 1948 until his retirement in 1973. The Warren Co-op was torn down in 1995. (WHS)

Canadian-born John H. Wilson (1858–1934) and German-born Lizzie Kreger Wilson (1863–1951) are pictured here in 1905. John Wilson operated the flour mill from 1895 until 1911, when he sold to A. V. Church. The Warren Farm Bureau Local then purchased it from Church and reorganized under the State Cooperative Act, and renamed it the Warren Cooperative Company. The Wilson home was on this property north of Chicago Road. (WHS)

This picture was taken on the wedding day of Martha Block and George Hartsig. There were several members of the Hartsig family in Warren, both in the Center Line area and Warren Village. In early written accounts and atlases, the surname is spelled as Hartzig. Grandfather Lewis Hartsig was an attorney and one of the founding members of the township. In the 1850 atlas, a sketch of the house between Ten and Eleven Mile Roads shows train tracks on the western property line; plank sidewalks were added years later. (WHS)

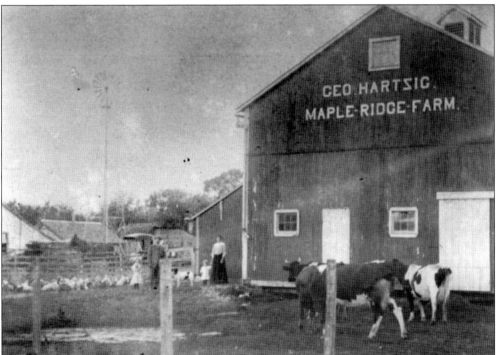

Maple Ridge, the name of the Hartsig farm, covered 80 acres where cattle, chickens, vegetables and fruits were raised. Here, Martha and George are standing to the left of the barn with their two children and a dog. Louis Hartsig, Esq. and William E. Hartsig are both listed in an 1890 census as farmers. In 1916, W. E., Jacob F., and George are all shown with property on the north side of Eleven Mile Road, across Van Dyke from the Township Hall on the southeast corner. (WHS)

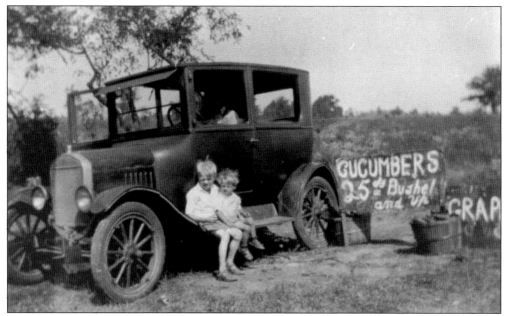

Roadside stands are still popular today in rural areas. The man behind the wheel may be testing the sales method of using cute children to draw customers. Farmers also went to Eastern Market in Detroit, and needed to diversify their crops to make the most of their business. According to Art Bierman, who grew up in Warren, "You were never a one-vegetable farmer. If tomatoes are selling, cabbage isn't; if lettuce is a flop, spinach isn't." His father Joseph wanted the children to be educated and learn his business, so took them along to the market. (WHS)

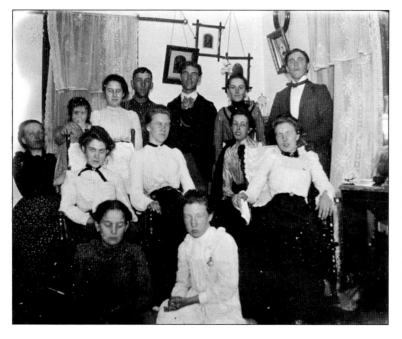

An example of a late-19th century farmhouse interior is seen here. This family must have been doing well enough to purchase the organ shown in the background, a model in which the decorative woodwork at the top makes it immediately identifiable. (WEA)

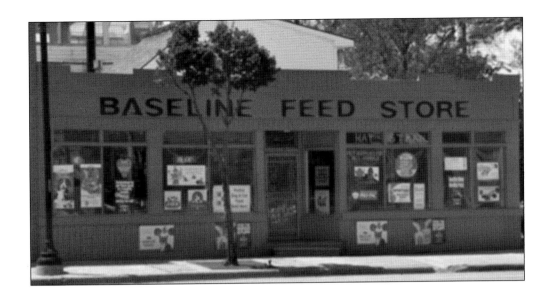

Base Line Feed at 21015 Van Dyke Avenue has provided the area with feed for farm animals and pets since the early 1800s. The interior is still largely the same with stamped tin ceilings and wide plank floors. Joe Verheye Sr., Cam Verheye, and Joe Verheye Jr. ran the store in 1944; Cam's nephew Chris Harvey runs the store today. Below, feed is piled onto the store's truck for a wintry delivery. At this time, the store sold feed to a still operable but shrinking agricultural community. The Verheye family has owned the store since 1927. (WHS)

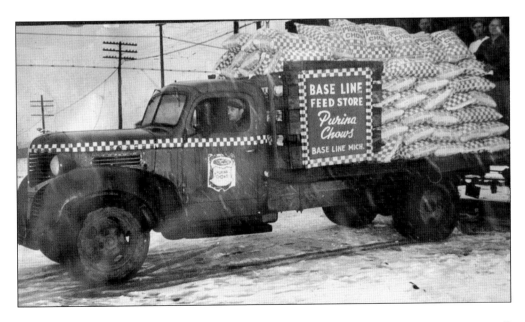

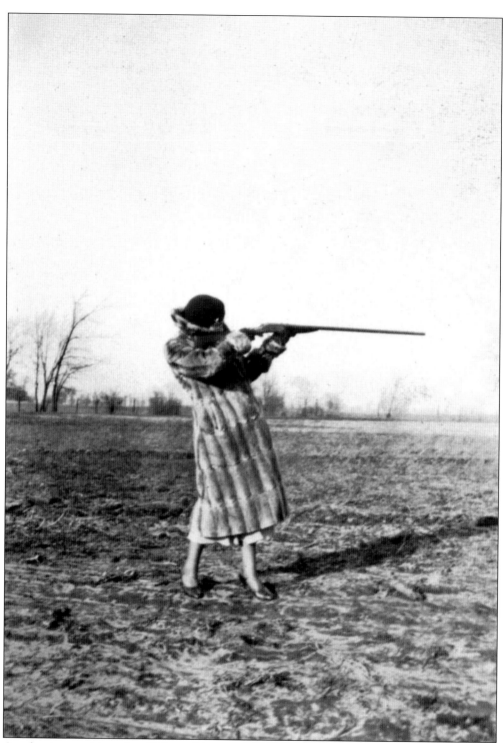

Another juxtaposition of rural life amid the growing urban-centered culture is this 1930s photograph of Leta Gloede, very stylishly practicing her aim on the John C. Gloede family farm in the still mostly rural Warren Township. The area still had a sizeable agricultural presence into the 1950s. (WEA)

Halmich farm, originally settled by William Halmich, was located at the northeast corner of Twelve Mile and Mound Roads. Water for the family and livestock was pumped about 70 feet to the surface by a windmill. West School, also known as Halmich School, was built on this property and is pictured on page 81. In 1944, Henry and Emma Halmich sold the farmstead, known as Clearview, to General Motors to make way for their new Technical Center. The school district had long grown out of this one-room schoolhouse by the mid-1900s, but it stood until the farmstead was torn down. (WHS)

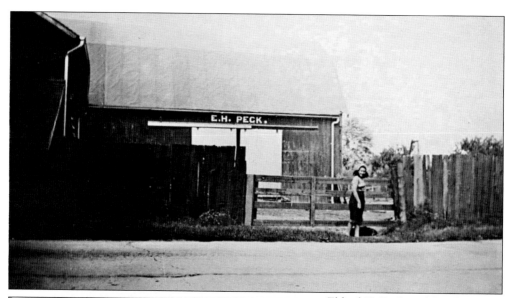

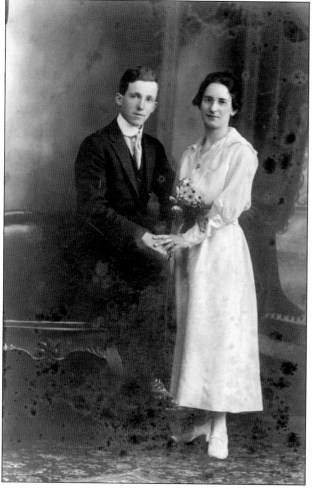

Eldred H. Peck and family settled in the western part of the village of Warren directly north of the Union Cemetery. Eldred was born in Warren in 1894; his father came from upstate New York and planted apple trees, among other crops. Eldred's half-brother Frank was the proprietor of the Peck Store on Main Street. Above, a neighbor stands in front of the farm that bears the family name. (WHS)

Eldred H. Peck and Myrtle Wilson are pictured here on their wedding day on September 19, 1917. Myrtle was the daughter of John Wilson, who founded the flour mill that later became the Warren Co-op. The Pecks had three children, Dorothy, Don, and Lynn, who died when he was just 15 years old. (WHS)

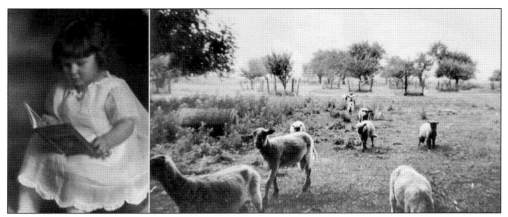

Young Dorothy Peck Cummings looks doll-like as she studies a book in this 1926 portrait. To the right is the flock that might have been on the farm that very day. The family always had horses because they didn't use tractors, along with cows for cream and about two dozen sheep. They also grew apples, among other crops. Young trees were fenced in to prevent sheep from nibbling on the leaves. (WHS)

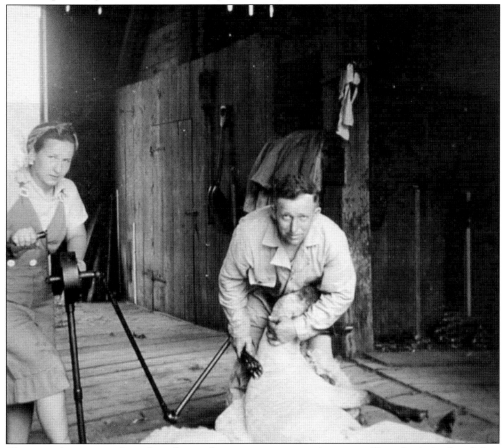

Shearing sheep was a big job and it took two to manage it. A teenage Dorothy helps her father by providing the power that allowed him to shear the sheep. After filling long burlap sacks with wool, they took them to Warren Station for transport to the Frankenmuth Woolen Mills, which is still operating today. (See page 101.) (WHS)

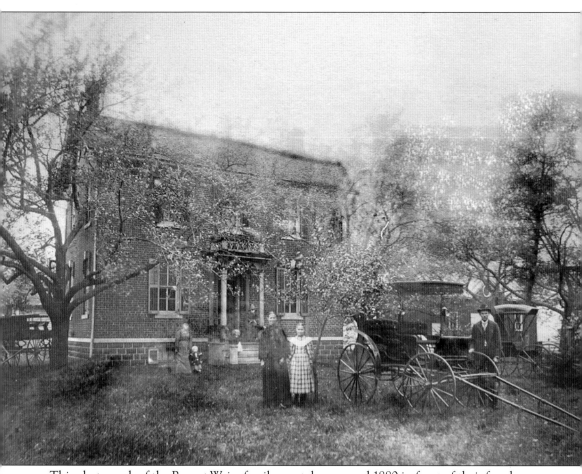

This photograph of the Bunert-Weier family was taken around 1880 in front of their farmhouse, which was established October 9, 1849. There are three carriages in view. Many of the outbuildings still exist today, as well as the original covered well at the entrance to the property. In 1949, a sign was created for the Centennial Farm by the Michigan Historical Commission. To the right of the house, not seen here, is a freestanding dinner bell that must have gotten plenty of use since 1849. In the 1950s, the Weier family began selling their acreage to Macomb County Community College, retaining the saw mill and wood lot that dated back to the mid-1800s, until it eventually gave way to the expanding school property. (WHS)

This color plate can be found on the cover of the *Detroit News Magazine* of January 11, 1948. A caption directed the reader to an inside page to see how Robert Weier "mastered the secrets of growing winter rhubarb." Macomb County was known as the rhubarb capital, along with an abundance of lumber and crops such as grain, corn, wool, and potatoes. The ad effectively captures the idyllic years following World War II with a carefree child playing in the snow, and the warm, beautiful Bunert farmhouse in the background. By 1948, there had already been four generations of Bunerts and Weiers, who had occupied this house since 1872 and the property since 1849. (WHS)

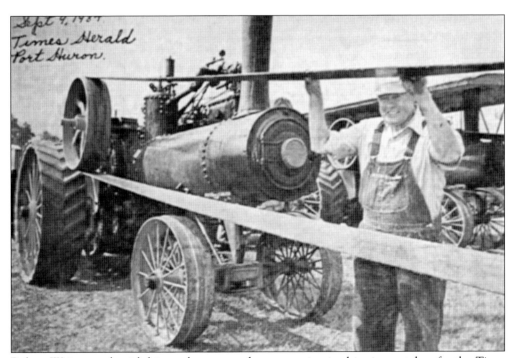

Robert Weier stands with his newly renovated steam engine in this picture taken for the *Times Herald* of Port Huron, September 9, 1984. Robert had moved to Armada while Herman remained in Warren. The 1922 engine was part of an exhibit of antique farm equipment. (WHS)

This is one of the Rinke farmsteads around 1940. The Rinkes were prolific in the township; this gives a partial view of one of the sprawling family farms. Joseph Rinke had land at Ten Mile and State (Sherwood) Roads, at Thirteen Mile Road west of Schoenherr Road, and at Thirteen Mile Road and Van Dyke Avenue. To the right, not seen in this picture, a Ford sign heralded things to come, as a side-by-side example of rural life and developing businesses, especially the burgeoning automotive industry. With the rising need for car dealerships, the family not only explored the business possibilities but became known for them in Warren. (WEA)

Four

BUSINESS AND INDUSTRY

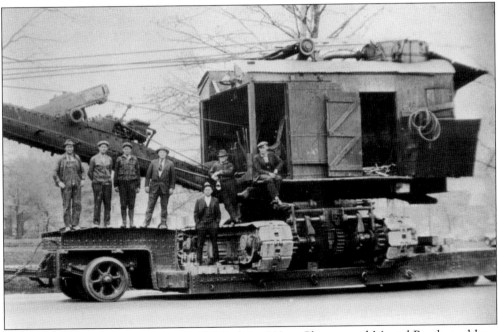

F. A. Warblow and Company was established in 1922 at Chicago and Mound Roads, and later moved to Chicago Road west of Van Dyke Avenue. The company did most of the sewer and water contracting in the area and in much of the state at that time, except the city of Detroit. Officers besides Fred Warblow (president and treasurer) were Amanda Warblow (first vice president), and Myrton Lyons (secretary and second vice president). Pictured here from left to right with Warblow's equipment are Oscar Busch, unknown, William Pennow, Fred Warblow, unknown, Earl Marlow, and Lloyd Fritz. The men were en route to putting in a water main in 1926. (WHS)

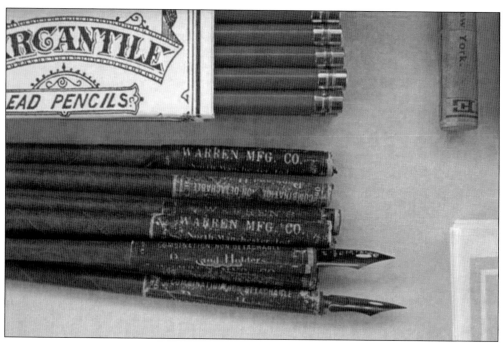

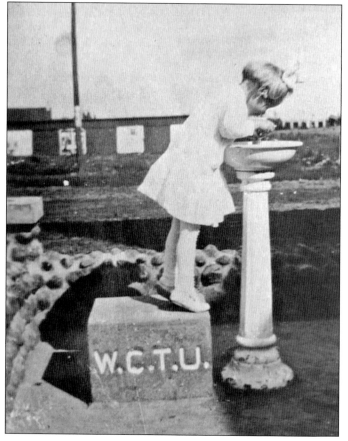

Warren Manufacturing Company of North Manchester, Indiana, produced these writing implements of the type used every day at the one-room schoolhouses. They are tightly rolled paper holders for pen nibs that were then dipped into inkwells. They are on display at the Bunert Schoolhouse near Martin Road. (WHS)

Watching out for the well-being of Warren's citizens was business of another kind. In this case, the Women's Christian Temperance Union WCTU) placed water fountains around the city during Prohibition to encourage a sober alternative for anyone feeling the need for a cool drink. (WHS)

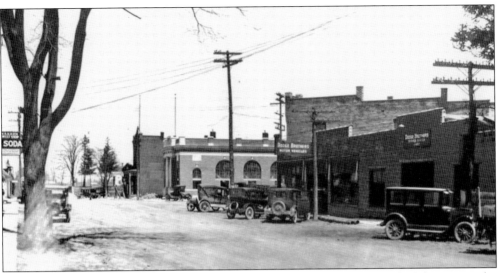

This is a view of Main Street (Mound Road) looking north around 1920. On the left are a popular sweet shop and the Dodge Brothers auto sales and service station. Dodge had expanded in 10 years to twice its original size. North of the bank was another car dealership—Chrysler—but signs of a merger were not even a thought at that time. (WHS)

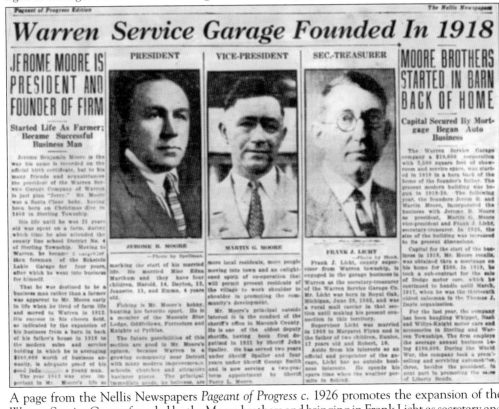

A page from the Nellis Newspapers *Pageant of Progress* c. 1926 promotes the expansion of the Warren Service Garage founded by the Moore brothers and bringing in Frank Licht as secretary and treasurer. This is one of the only professional pictures of Licht, who was visible on just about every civic board as well as being a letter carrier, lamplighter, and Exchange Club member. (WHS)

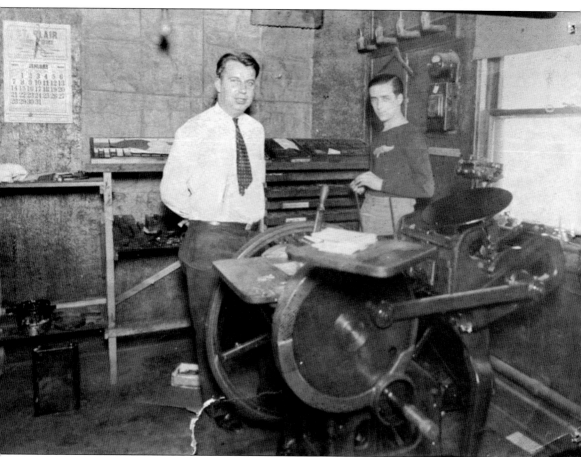

Here civic leader and historian Harold Stilwell pauses with apprentice Jack Aumann to capture a moment in his printing shop at the corner of Warren Boulevard. The structure resembled a house more than a commercial building with the Stilwell Press occupying it from 1932 to 1946. Note the printer's boxes in the background. Bea's Lunch was in a smaller structure attached to this building, which later became Joe's Party Store. Bea's, with four stools, was considered the first restaurant establishment in Center Line, but since there was no refrigeration, she only bought one pound of meat at a time. This building was at the loop for the electric railway at Ten Mile Road and Van Dyke Avenue on the east side, so Bea was open 24 hours a day. (WEA)

COMMERCIAL

model office

The Commercial Department's aims for education of the students are varied. We have an excellent program to prepare a student for a stenographic position after graduation, with other necessary courses to make that person well qualified to meet the demands in the field of business.

Another plan in our department is to provide a good basic commercial education for those who desire office employment but do not wish to do stenographic work.

A group in the student body that we are interested in includes the student who has not decided just what he would like to pursue after graduation, so we provide that student with the basic business fundamentals in typewriting, bookkeeping and other classes of his choice -- to be used in the business world or for his own personal use.

A co-operative training program in office and retailing gives our students, while still in school, an opportunity to explore the many facets of business through actual work experience.

Finally, we strive for the development of the student to meet and adjust with the ever-changing and challenging society by the encouragement of advanced study after the student leaves Fitzgerald High School. R. Jackson
 Chairman

JOHN GUTKA

DONALD LEVERENZ

ROY JACKSON
Chairman

ROBERT LITTLE

AGNES MURPHY

EVELYN SCHROEDER

This was a page from a 1960s yearbook on which the Commercial Department stresses the skills taught at Fitzgerald High School to prepare their students for work in any modern office, including stenography, typewriting, bookkeeping, and other basic business courses of the day. (WEA)

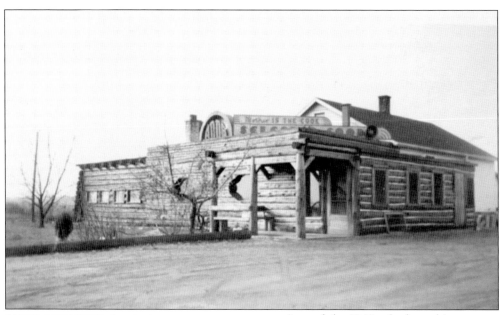

Around the 1940s, the log cabin restaurant known as Ann's Galley served food morning, noon, and night. The plaque at left was displayed at the entrance and was the owner's way of making everyone feel at home, and setting the tone of this establishment. Ann's was also known as Ann's Tavern. Located at 24365 Mound Road between Nine and Ten Mile Roads, it was also an especially popular spot for Tech Center and Truck Plant employees in the 1950s. Charles Grimes, the owner's husband, always known as Charlie, had a barbershop in Warren Village. It is evident that the restaurant changed hands by an advertisement in a 1954 yearbook showing that address as Mary's Grill. (WEA)

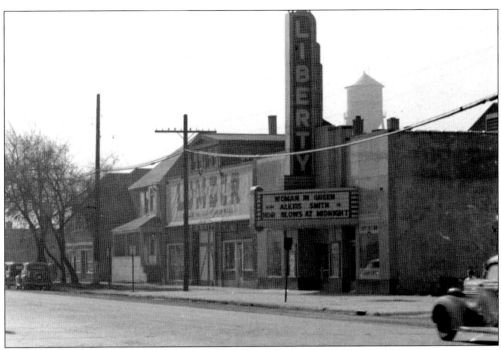

The Liberty Theatre was located in the heart of Center Line with J&J Vending contracted for the food concession. Sources remember the beautiful organ costing $8,000, which seemed like quite an extravagance during the Great Depression. Next door is Robinson's Lumber, which later became Gibbs Lumber. Grissom's auto repair shop took over the Liberty in the late 1950s. (WEA)

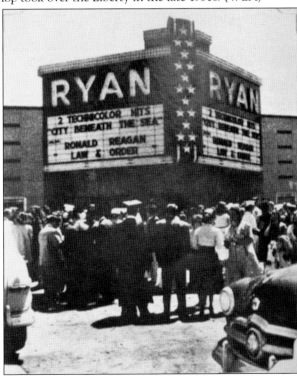

The Ryan Theatre came along in the early 1940s and is on Ryan Road just south of Nine Mile Road. A photograph in the 1954 *Spartan*, Fitzgerald High School's yearbook, shows graduation at the Ryan before the high school auditorium was built. The marquee suggests that Ronald Reagan's aspirations had not yet reached as far as the White House, and Technicolor was Hollywood's latest innovation. One resident remembered that as a young man, he and a friend used to take "the fast way" to the theatre by ice-skating on Bear Creek. (WEA)

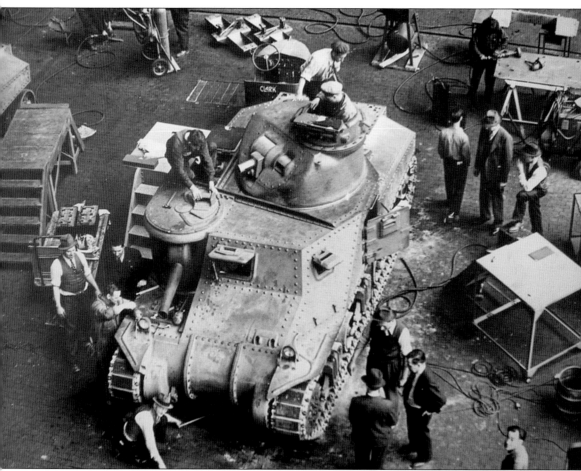

Men are seen at work at the Chrysler Tank Arsenal around 1942. The plant was designed by architect Albert Kahn and erected in an impressive seven months at a cost of $20 million, the largest of its kind in 1941. Seven men were required to assemble each tank. Built on 113 acres, the main plant structure is 1,380 feet long and 500 feet wide. About 95 percent of the factory envelope was glazed to provide natural lighting and ventilation for the work areas. Along the entire north wall was a railroad track for efficient loading and unloading. (Albert Kahn Associates Inc.)

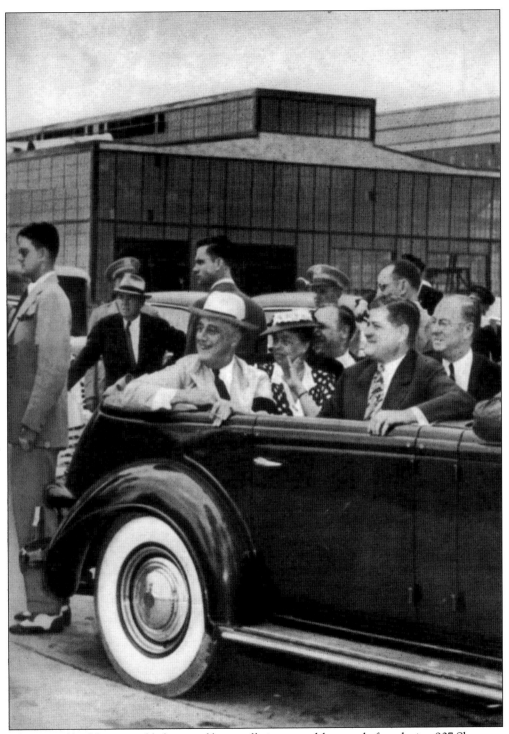

The arsenal had five assembly lines and hit an all-time monthly record of producing 907 Sherman tanks. Franklin and Eleanor Roosevelt visited the plant on a tour of the country's defense facilities. At that time, Roosevelt declared the Warren Tank Plant "The Arsenal of Democracy." (WHS)

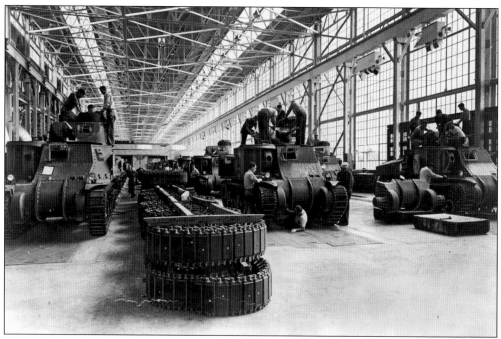

This extremely efficient facility is widely credited with helping to win World War II. Saarinen, Swanson, and Associates built the innovative Kramer Homes project at Ten Mile Road east of Van Dyke Avenue as a response to the need for employee housing. Eliel Saarinen and his son Eero would later build the General Motors Technical Center. A partial plan of Kramer uses concentric circles and angles and included an educational facility as well as other support services, a new idea at that time. The complex is still a sought-after residential address. Seen below is an exterior view of the tank arsenal. (Albert Kahn Associates Inc.)

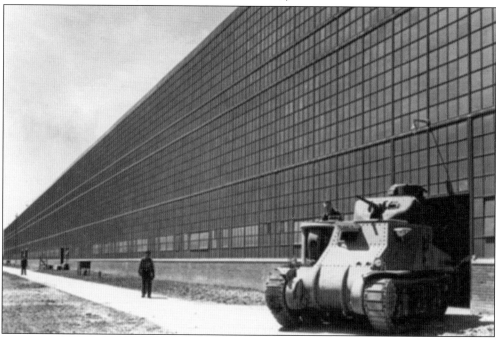

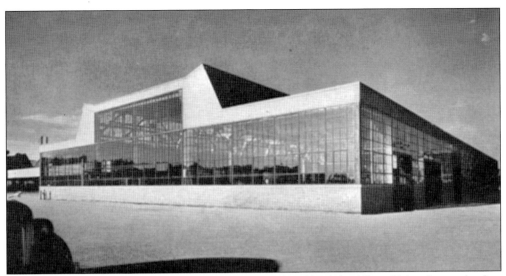

The Dodge Truck Plant was also ingeniously planned and built by Albert Kahn. It was the first automotive plant to have straight-through assembly, again saving money, time, and manpower. The plant opened for business at Mound and Nine Mile Roads with a production rate of 700 trucks per day. Its 50 conveyor systems extended a total distance of 7 miles. (Albert Kahn Associates Inc.)

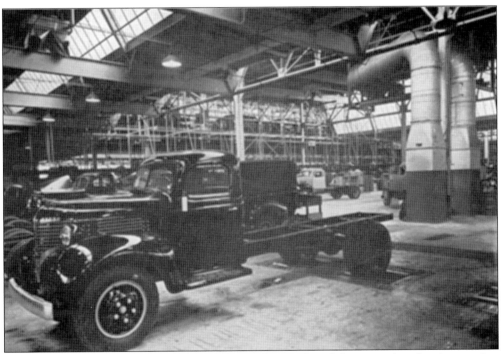

An interior photograph shows work on the Dodge trucks of the time. Another innovation attributed to Kahn was to bring in as much natural light and air as possible to the factory floor, transforming dark, often unhealthy environments into safer and healthier workplaces. Operable clerestory windows were a common sight, and the structures themselves were planned for the most efficient use of materials, time, and manpower. An entire elevation opened to the adjacent railroad tracks that served this plant. (Albert Kahn Associates Inc.)

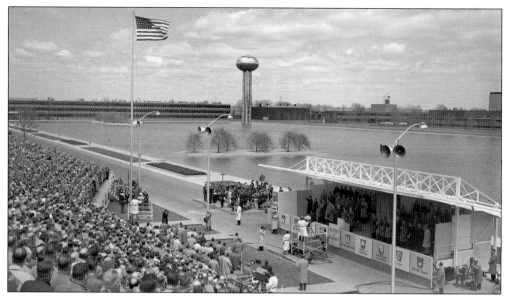

This is an elevated view of the May 16, 1956 dedication ceremony for the new General Motors Technical Center. The view is to the northeast and the GM Research and Development building can be seen in the distance on the shore of the artificial lake. Designed by Eero and Eliel Saarinen, this was one of the first major complexes in the United States to use glass curtain walls and was built in the International style of architecture. The two million square feet of built space required its own water tower for fire protection. The formal dedication ceremony was attended by 5,000 guests who listened as President Eisenhower addressed them from the White House via radio. (GMC)

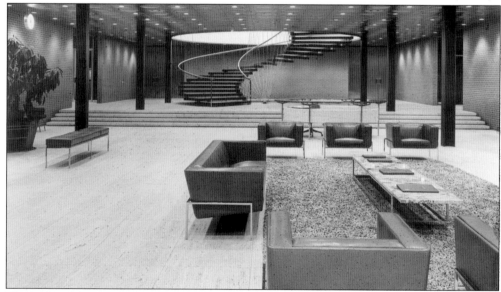

The lobby of the Research and Development building included a masterpiece of engineering in what was nicknamed the "floating staircase." Its steps of seven-foot, four-inch terrazzo overlap each other and are suspended from above with stainless steel rods, resulting in a large-scale sculpture lending a lightness to a lobby designed in high-style modernity. Saarinen also helped to develop the first luminous ceiling to eliminate reflection and shadow, especially used in the drafting studios and styling areas. (GMC)

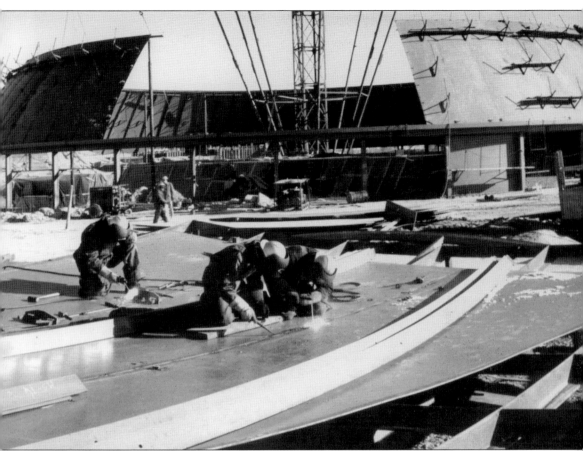

In 1956, this GM complex was home to 16,000 engineers, designers, and technicians. The domed auditorium of the design center allowed for viewing of cars under a variety of lighting conditions. The 65-foot-high dome spanned 186 feet. The dome itself was constructed with aluminum plates attached to the base by a tension ring, which also supported the interior acoustic dome that served as a ceiling for the styling auditorium. The wildest dreams became reality here. This became a great venue as well for the unveiling of concept cars and the latest milestones in luxury road travel. Upon its dedication, *Life* magazine dubbed the Tech Center "The Versailles of Industry." (GMC)

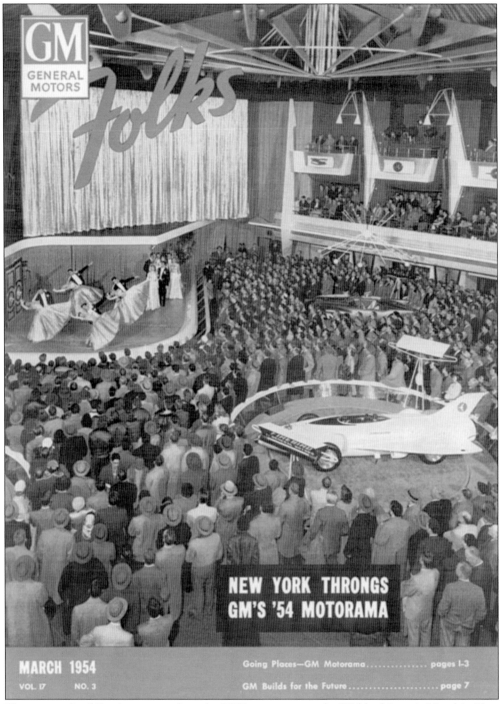

GM GENERAL MOTORS *Folks*

NEW YORK THRONGS GM'S '54 MOTORAMA

This internal publication reported on the 1954 motorama at the Waldorf Astoria Hotel in New York City. Traveling motoramas and futuramas were hugely successful annual events, introducing new product innovations, styling, and concept cars from the GM Tech Center in Warren. These were presented amid music and dancing, and were much-anticipated social events. Note the futuristic Firebird featured here. (GMC)

Five

SACRED PLACES

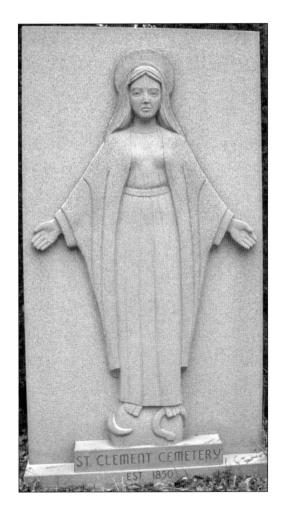

This beautiful stone bas-relief is seen upon entering St. Clement Cemetery east of Van Dyke Avenue at Engleman Street, directly behind the church of the same name. The cemetery was established in 1850 and some of the earliest members of Center Line and the village of Warren are interred here, including Louis and Charles F. Groesbeck, Hieronymus Engleman (first Center Line postmaster in 1878), Rev. Abel Warren and wife Sarah, Joseph and Sophia Buechel, members of the Hayes, Ryan, and Schoenherr families, and many more settlers in the area after whom the streets are named. This beautiful monument was donated by William Woodruff, a local citizen and businessman, in 1985. (WEA)

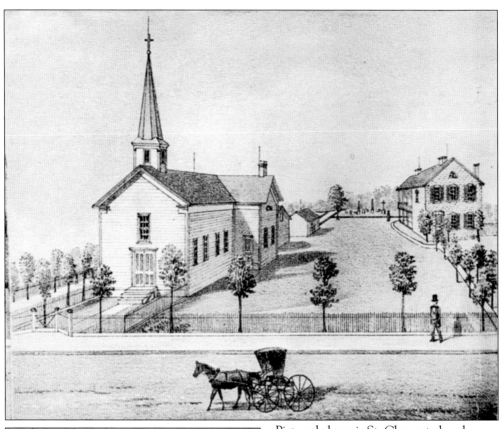

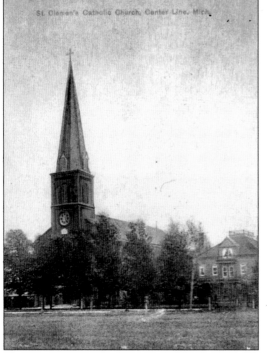

St. Clement's Catholic Church, Center Line, Mich.

Pictured above is St. Clement church on the east side of Van Dyke Avenue and Engleman Street. The sketch was published in the 1875 atlas maps, and was entitled "Father Hendricks Church and Residence." Prior to the church's construction, roads made traveling to churches in Detroit very difficult, especially in the rain. The faithful would meet for the occasional Sunday mass at John Buechel's store at its original location on Nine Mile Road and State Street (now Sherwood Avenue). The area was known as Kunrod's Corners then, and was to have several names in its future. (WHS)

The exterior of the second St. Clement church is seen here in 1900 with the recently-built rectory directly to the right. Twenty years earlier the original frame church had been replaced by this large brick edifice that featured a magnificent pipe organ. Father Hendricks was alive to see this parish flourish and grow. (WEA)

The rectory, shown above, is to the right of the church. The new church was dedicated in 1880. It was 136 feet long and 54 feet wide, and was constructed at a cost of $18,000. There were five entrances, 15 stained glass windows, and many paintings and frescoes. It was the tallest structure in Warren, and could be seen for miles around. Ethel Schoenherr Jenuwine lived at Seventeen Mile Road and would go with her family and friends to St. Clement every Sunday on "good gravel roads" after 1917. They'd make a day of it, though, as 7 miles was a long way to travel; in winter they'd take bobsleds. Below is the only known interior photograph of the second church. (WEA)

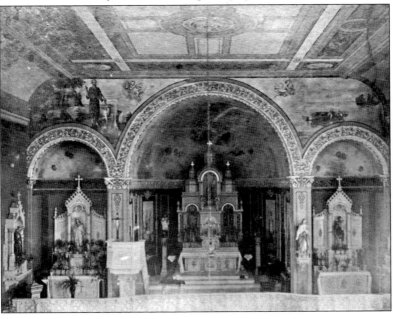

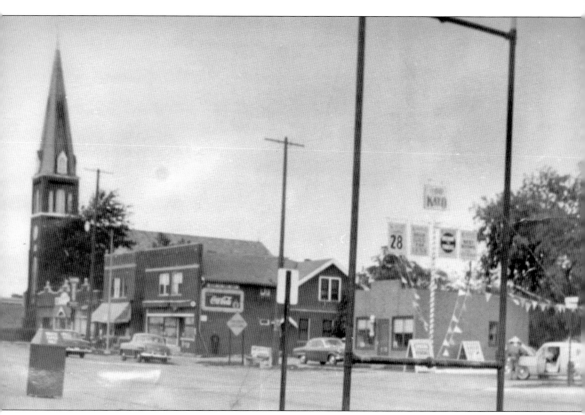

In an article dated Saturday, March 4, 1967, it was reported that Joseph Rinke and sons Edgar and George began their car dealership empire just north of the church. Originally shared with Michael Smith, there was a hardware store on the lot, and then car dealerships. The same basic business is there today. This second edifice for the parish was the first building to come down as part of an urban renewal program. The parish house was demolished in 1961 to make way for the modern church that is seen today. Note Buechel's store with the awning. (WHS)

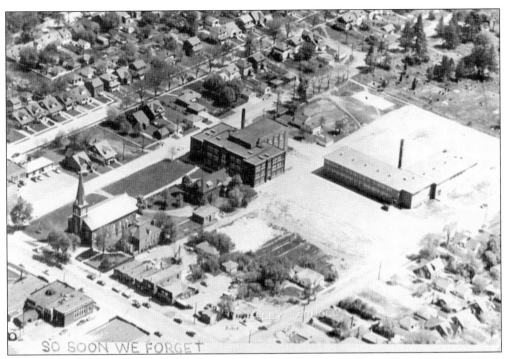

This 1954 aerial view shows the St. Clement parish grounds and the surrounding neighborhood. The end of an era was marked by the demolition in 1960 of the adjacent commercial buildings, including Buechel's store (shown in the middle of the block facing Van Dyke Avenue), to make way for the third St. Clement Church. The parish school buildings are in the rear and the cemetery is just visible on the top right corner of the photograph. Engleman Street is to the left of the church. (WEA)

The new, modern church with the blue roof sits where the retail establishments once were. Ritter Street is to the right, Van Dyke Avenue is in the foreground, and today's Rinke Toyota is to the left, out of frame. Where the church and rectory once stood is now a parking lot for parishioners. (WEA)

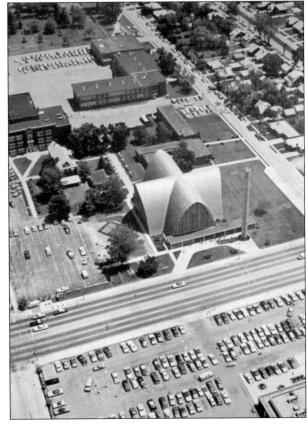

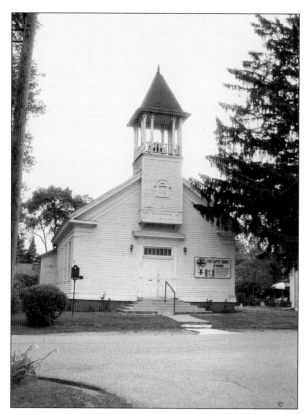

Warren Methodist Episcopal Church was built in 1857 and moved to its present site at Seventh and Filmore Streets in 1884. According to a 1921 article in the *Pageant of Progress*, a Nellis Newspaper, the Baptist and Methodist congregations shared a log schoolhouse at Chicago and Ryan Roads from 1849 to 1852, alternating Sunday services. Inside were split log benches around the perimeter. A church was then built east of Union Cemetery until its move to the current location. During the move, rough roads necessitated a stop to reinforce the structure with iron rods before it could continue on its way. After a disagreement with the pastor here, Elisha Halsey and her husband began the Free Methodist church that was constructed on the lot where Fred Lutz's hardware store was located in 1923. The parsonage, shown below, is on Filmore Street and exists today as a private residence. (WHS)

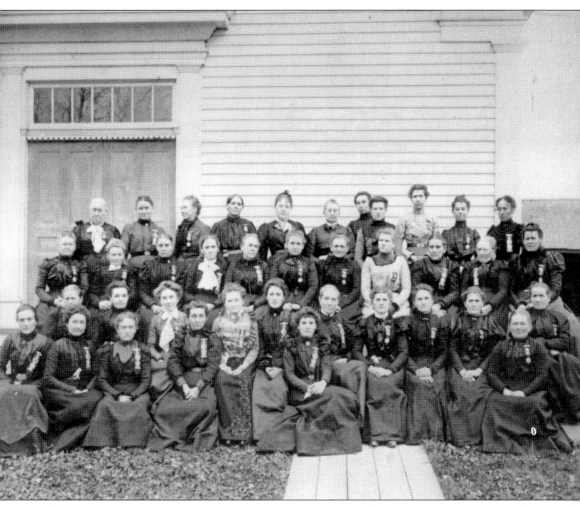

Ladies of the Maccabees are pictured in front of the Methodist church around 1900. Mrs. Frank (Elisha) Halsey is in the front row, second from left and right of her is Sarah Ames. Sixth in from the right on that row is Dr. Flynn's wife Anna. In the second row on the left is Mrs. Robert Tharrett and second from the right is Mrs. Hoard. At present, Elliot Funeral Home occupies the Hoard residence on Mound Road that dates to 1889. The woman in the top row, first on the left, is identified as "Old Mrs. Harwood," Mrs. Steffens is next to her, and fifth from left is Homer Harwood's wife Etta. Mrs. Reddick is to the right of her, and again to the right is Justie Rivard. (WHS)

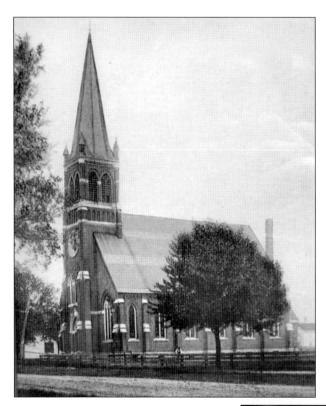

A postcard of St. Paul Evangelical church from around 1940 on the east side of Mound Road shows the original steeple. There were 11 pastors at St. Paul between 1864 and 1923. Tenure for pastors here was generally from two to ten years in duration. Due to lightning damage in 1921, the steeple had to be removed. German services were held here until 1935. (WHS)

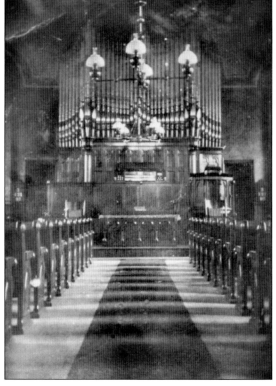

This old interior and the photograph on page 16 are the only known surviving photographs of these views. The congregation was organized in 1864 by Rev. Phillip Werheim, but had met in the Methodist church across from Mound Road, as an outpost of St. Peter's Episcopal of Halfway in the mid-1800s. Halfway is Eastpointe today and was so called for its location on Gratiot halfway between Detroit and Mt. Clemens. St. Paul has remained in the same location since 1864. Rev. Werheim served as its pastor from 1864 to 1866. (WHS)

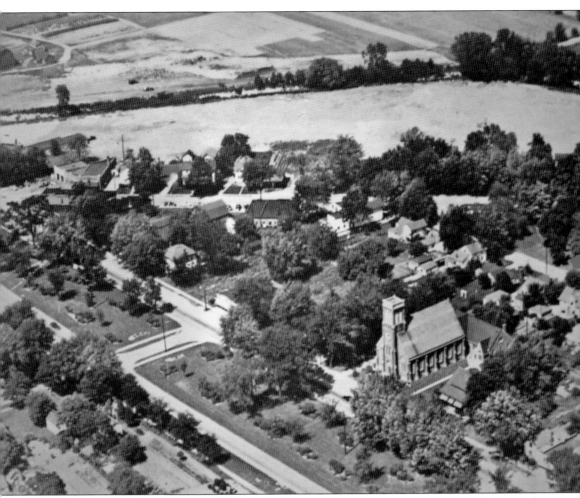

This aerial view shows a greatly changed St. Paul church without the steeple. Mound Road and other traffic corridors were widened in the mid-1940s after construction of the General Motors Technical Center. The Red Run Creek can be seen from left to right in the upper portion of the photograph. The church and surrounding properties are situated on a large 30-60-90 degree triangle made up of Beebe Street to the south, Mound Road to the west, and Chicago Road to the north and rear of the church, angling down toward Thirteen Mile Road and completing the triangle. (WHS)

A sacred place was discovered when a local company was digging around the foundation of its new building. A bone, later determined to be a human femur, was found along with the stone that went with it. The name of this location is being withheld out of respect for the deceased. This was a 15-year-old child and with 1919 as the date of death, it is very possible that flu was the cause. The flu epidemic in the United States saw the highest number of casualties in 1919. The body may have simply been buried in the yard, a not-uncommon occurrence during an epidemic of this magnitude. (MRB)

This understated entrance into the Detroit Memorial Park Cemetery (DMP) on Thirteen Mile Road is just east of Ryan Road. In 1925, to counteract the indignities and poor service offered to the black community, mortician Charles Diggs, along with druggist Dr. Aaron Toodle and other funeral directors and morticians in Detroit, purchased 60 acres of property here for the purpose of providing dignified burials to the African American community. The DMP saw its investors through the Great Depression and grew to three sites, with doctors, lawyers, scientists, ministers, teachers, and business, civic, and political leaders interred here. (MRB)

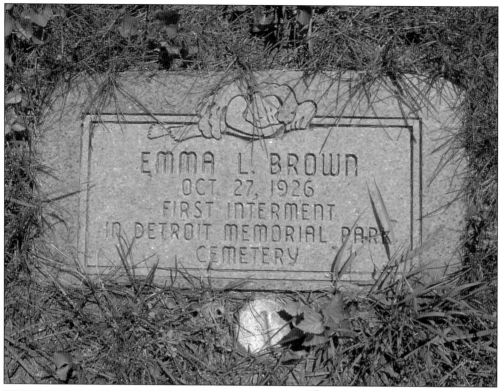

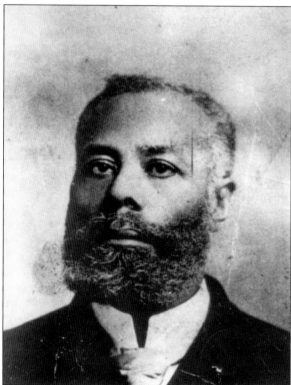

The surrounding community was putting pressure on the city to reverse the sale of this land to the cemetery association. Knowing that it would be much more difficult to do so if there was at least one burial on the land, Emma Brown, stillborn on October 22, 1926, became the cemetery's very first interment. She is buried in section 1, plot 1. (MRB)

Inventor Elijah McCoy is one of the more prominent deceased buried at Detroit Memorial Park Cemetery after his death on October 10, 1929. McCoy was born in Ontario, Canada, on May 2, 1844, to parents who had fled slavery in Boone County, Kentucky via the Underground Railroad. Elijah graduated from Howard University and went on to invent and own the patent for a lubricating system that was used worldwide. In his lifetime, McCoy had 78 inventions and 48 patents. (YHS)

Many of Warren's early settlers are buried at Warren Union Cemetery, including the Berz, Langel, Peck, Hoxsey, and Licht families. The lot is accessed on Chicago Road and is at the western most boundary of the historic district today. Farmer Peter Gillette sold the original parcel to 18 families for use as a burial ground, and the Warren Union Cemetery Association was organized in 1852. This is the oldest cemetery in the city. Eldred Peck sold additional land in the early 20th century, and his granddaughter Dorothy Peck Cummings still conducts regular walking tours. (WHS)

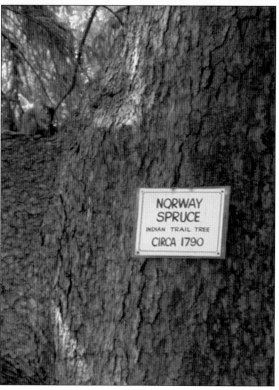

The Norway Spruce is one of what are known as Indian trail trees, said to lead the way to Native American burial grounds. And indeed this one does, as a burial ground was discovered in the 1970s on the Bunert property in the northeast part of the township. This area was accessed by the Moravians, who came inland by way of Lake St. Clair. Comparing early and current maps, one can see where Chicago Road and Moravian Drive were probably connected at one time, basically following the Red Run Creek. The tree, more than 200 years old, is massive, with thick limbs appearing to point the way. (MRB)

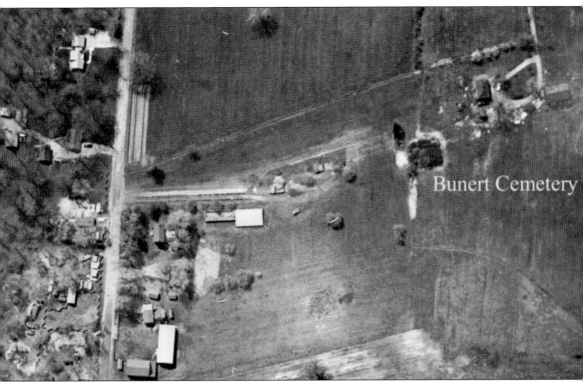

Bunert Cemetery

Warren's first cemetery had the remains of pioneer families such as the Theuts, Hessels, and Schoenherrs, and before that, what is believed to have been remains of Native Americans. The entire rear portion of what is now the Bunert-Weier Centennial Farm was sold to Warren Woods schools for the construction of Briarwood Elementary School. A mound was discovered by children, who then went to the police. The cemetery had the remains of at least 40 bodies. Carl Weier and William DuRoss of DuRoss Funeral Home led the removal of the remains. Weier is the son of Ida Bunert, who was in her 80s when the discovery was made and remembered that her grandparents were buried there. (WHS)

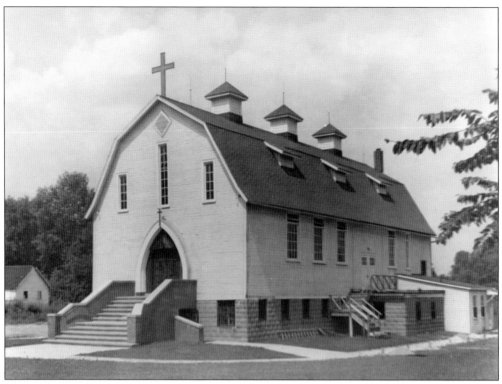

This Warren Village barn was purchased by the St. Anne congregation for $14,000 in 1945. A longtime resident remembers this as John Warner's hay barn on the south side of the Red Run Creek, two blocks east of Mound Road. Prior to this, parishioners met in a nearby storefront. The interior of the barn was converted into St. Anne Chapel, with statuary handed up through the hayloft opening and a community of tradespeople converting the barn to a sanctuary. (SACC)

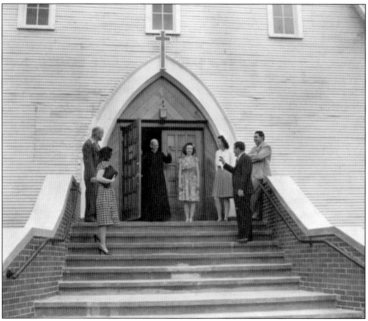

The first mass was said on Easter Sunday 1946. Here, Father Frank Walsh steps outside to mingle with parishioners. He died on September 19, 1978 but was able to see his dream of a permanent church and school realized. (SACC)

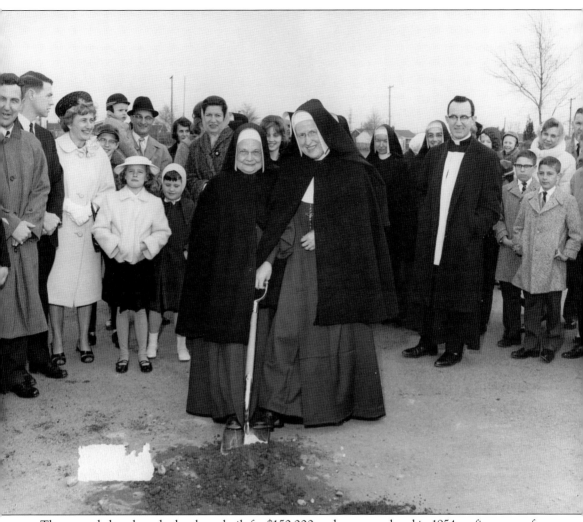

The second church and school was built for $150,000 and was completed in 1954 on five acres of land donated by Norman Halmich. Dr. Wilde's home at 5804 Arden Avenue was purchased and used for a parish house until 1958. This edifice was an auditorium/gymnasium-style temporary church. Ground was broken in April 1964 for the current stone church, which was completed in 1966. (SACC)

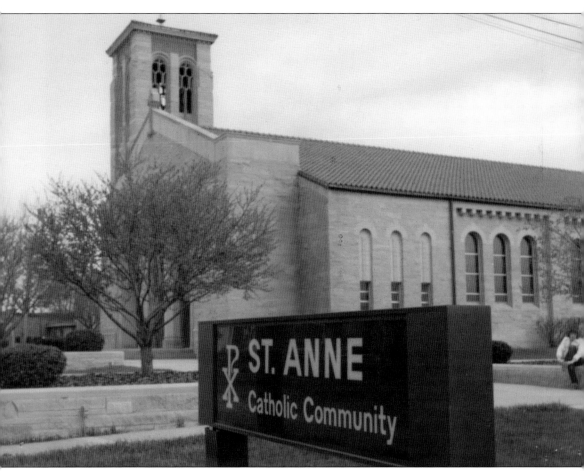

The parish was established with a membership of 210 with founding pastor Father Frank Walsh and help from the Dominican nuns from St. Clement church in Center Line. At its inception, the huge parish covered Twelve Mile to Sixteen Mile Roads and from Dequindre to Schoenherr Roads, and grew to a peak of 3,000 families in 1965. St. Anne Catholic Community continues to thrive today. (SACC)

Six

SCHOOLS AND EDUCATION

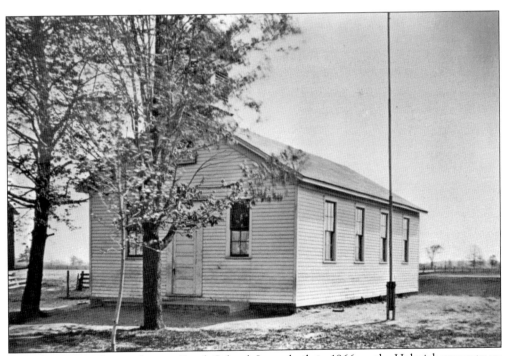

School No. 1 was known later as South School. It was built in 1866 on the Halmich property on the east side of Mound and Twelve Mile Roads. It was known as the Halmich School in the 20th century, and was torn down in the late 1940s to make way for the General Motors Technical Center. (WEA)

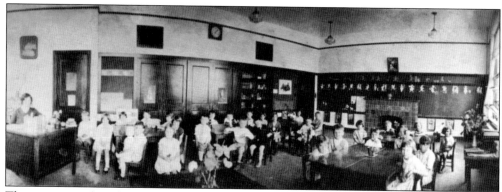

There are several grades represented in this classroom. Typically, time was spent with a general exercise, and then various grades went to separate tables. Younger children had help from the older students. At the lunch break, younger students could then go home, and the older ones went back for more advanced studies. A typical day went from 8:00 a.m. to 2:30 p.m. (WHS)

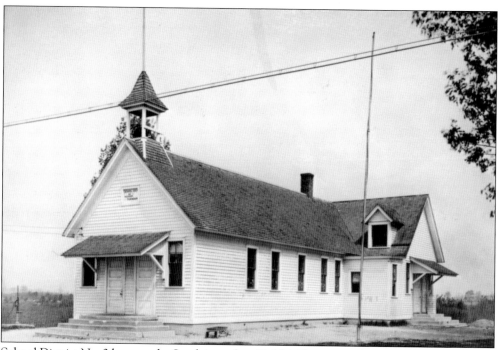

School District No. 3 became the Sandpiper, then Teddy's Tavern on Thirteen Mile Road west of Van Dyke Avenue. The original structure was hidden by brick facing put on later. Johnny Vegas' now owns the site, and none of the original school remains. (WHS)

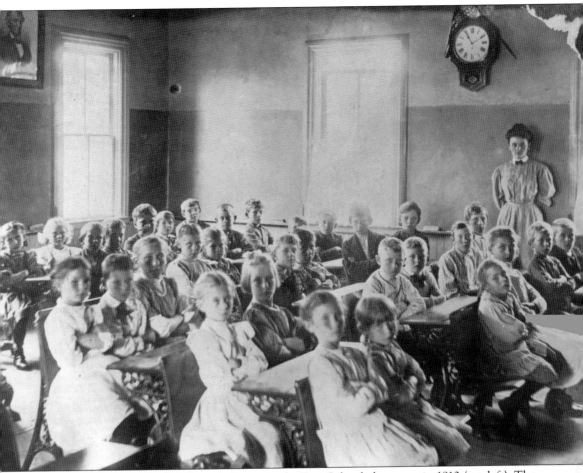

A large picture of President Lincoln hangs in the Berz School classroom in 1910 (top left). The desks were then manufactured as the writing surface with wrought iron brackets attached to a seat for the student in front. Judging by the serious facial expressions and the clock on the wall, it was probably close to lunchtime. (WHS)

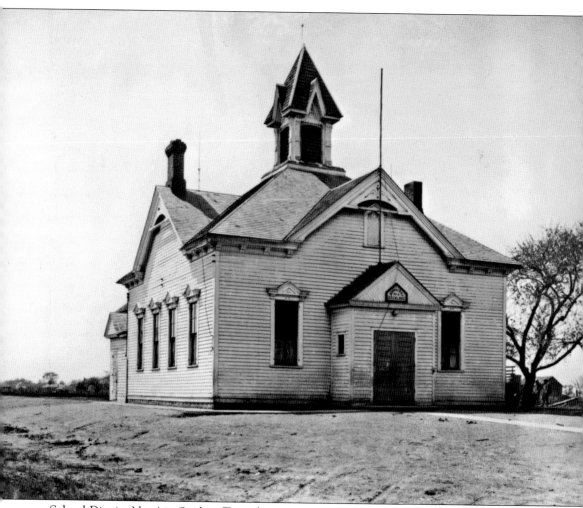

School District No. 4 in Sterling Township was established in 1859 on the west side of Mound Road south of Fifteen Mile Road, and became known as the Berz School. The school taught many of the children from the village of Warren. It became part of the Warren Consolidated Schools in 1941 and was sold in 1952. Members of the family of the same name are buried in historic Union Cemetery. Their plot is marked with a large charcoal stone with "Berz" boldly carved into it. The marker faces Chicago Road. (WHS)

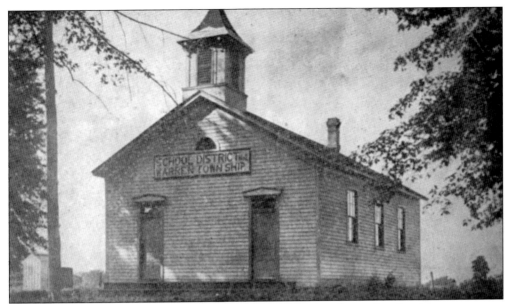

This is the only known image of School District No. 2, taken from a local newspaper account around 1900. It was also known as Plunkett School, complete with privies to the left of the building. It is thought to be one of the very first schools in Warren Township and was located at the northeast corner of what is now Sherwood Avenue and Ten Mile Road. The school was named after Mortimer Plunkett, who taught alone here for many years. In the 1920s, Busch School was built on this site and has seen many additions over the years. (WHS)

1922 TEACHER'S CONTRACT $75 MONTH

Not to get married. This contract becomes null and void immediately if the teacher marries.

Not to have company with men.

To be at home between the hours of 8:00 p.m. & 6:00 a.m., unless in attendance at a school function.

Not to loiter downtown in ice cream stores.

Not to leave town any time without the permission of the Chairman of the Trustees.

Not to smoke cigarettes. Contract becomes null & void immediately if teacher is found smoking.

Not to drink beer, wine or whiskey. This contract becomes null and void immediately if found doing so.

Not to ride in a carriage or automobile with any man except her brother or father.

Not to dye her hair.

Not to dress in bright colors.

To wear at least two petticoats. Not to wear dresses more than two inches above the ankles.

Not to wear face powder, mascara or to paint lips.

To keep the schoolroom clean: (a) to sweep the classroom floor at least once daily., (b) to scrub the classroom floor at least once weekly with soap and hot water, (c) to start the fire at 7:00 a.m. so that the room will be warm at 8:00 a.m. when the children arrive

This list was compiled from various teachers' contracts that showed compensation of $75 a month. Among other interesting stipulations to a teaching contract in the 1920s was the fact that the contract would be void immediately if the moral stipulations were breached. Adherence to these rules was seen as an indication of dedication and the ability to devote full time to the job at hand. (WHS)

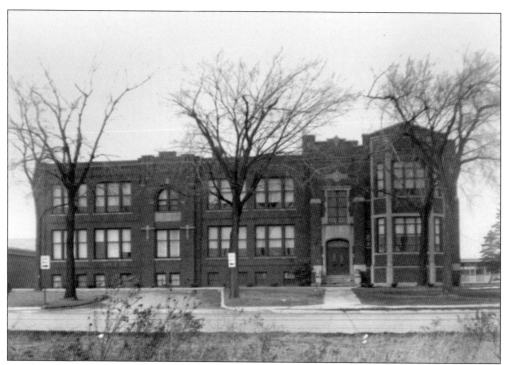

Busch School was constructed in 1921–1922. The school has had many additions since then, but originally it was a high school with grades 9–12. Warren Township families had at least two high schools to choose from—Murthum and Busch. When Center Line High School was built, Busch then became a middle school. Its architectural style is English Tudor, which was popular for the design of educational structures in the old-world Ivy League tradition. This projected a sense of stability and strength toward the country's educational system. Also seen here is the 1940s Busch School Band with Homer Hazelton as its director. (WEA)

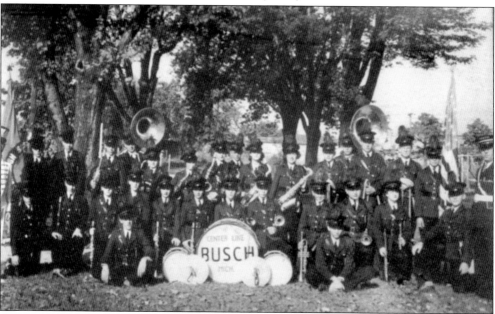

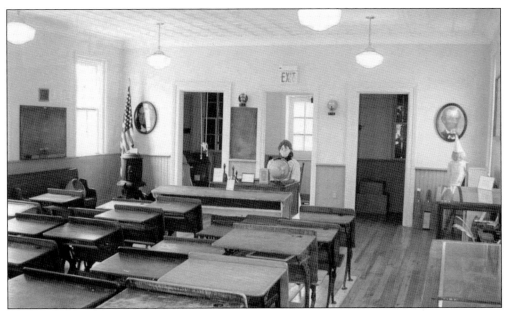

This is a re-creation of the interior of School District No. 4, Bunert School, around 1875. This structure stood on the Bunert-Weier property adjacent to the house on the east side of what is now Bunert Street, just north of Martin Road. At one point in the 1970s, the interior was partitioned to accommodate a small family. Abandoned and having fallen into a state of disrepair, the Warren Historical Society led a community effort to move the schoolhouse and restore it to its original condition. (MRB)

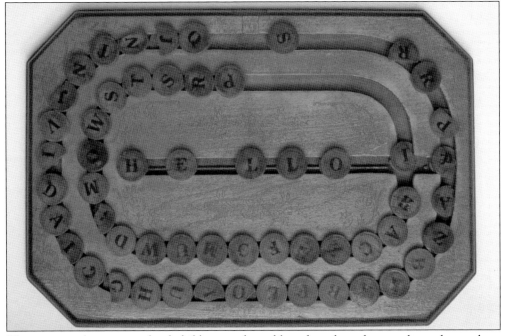

The younger elementary school children used word boards such as the one shown here, where letters can be moved and slid into place to form words. The letter board has a patent of February 16, 1886. (WEA)

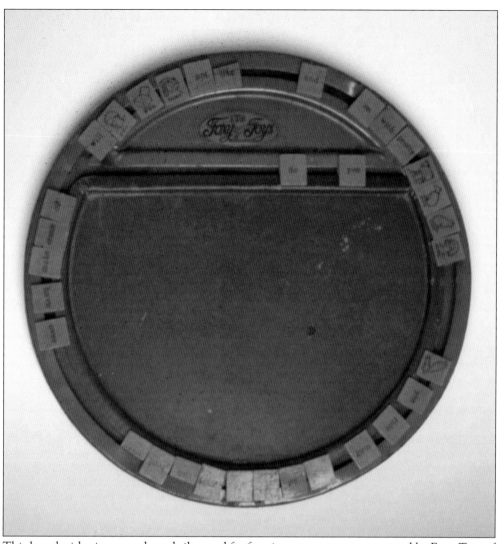

This board with picture and word tiles used for forming sentences was patented by Foxy Toys of Berea, Ohio, in 1917. Teachers in one-room schoolhouses usually worked with children of all ages and at various stages of development. (WEA)

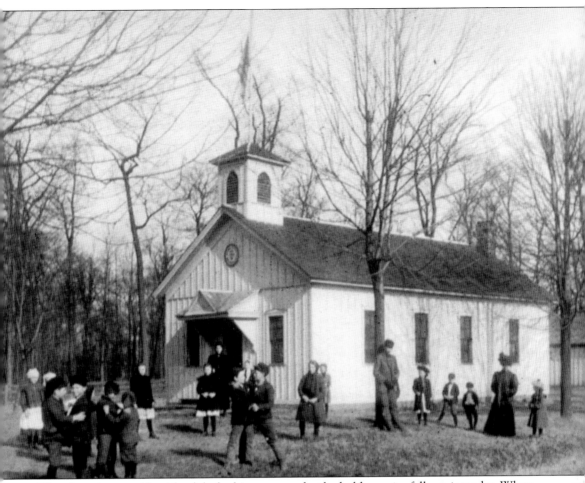

This class plays outside with adults looking on, on what looks like a crisp fall or winter day. When schools passed certain state qualifications, they became known as "standard" schools. Bunert Standard School consisted of two buildings in 1927, with a larger building added next door. Classes K through Four were then taught in the one-room building, with five and six in one room and seven and eight in another room of the two-room structure. There were three teachers, one for each room. Classes were held until 1944 when the six-room brick school named Charwood, after Betty Chargo and Irene Woodward, was built on Schoenherr Road. The two Bunert structures were bought by John O'Connor, who made them into residences. In 1970, they were sold to the Santa Maria Lodge. The larger building stands in its original location; the one-room structure was moved. (WHS)

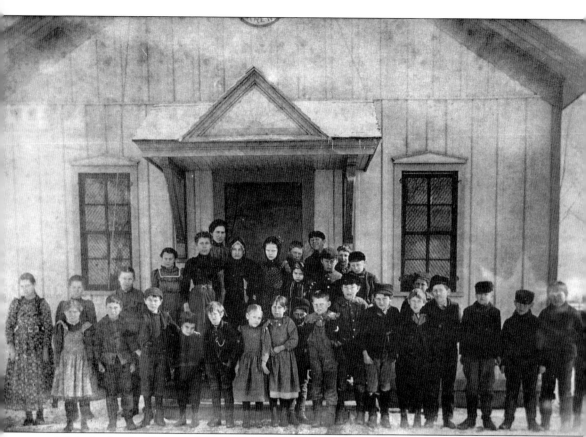

With the façade of Bunert School as a backdrop, this picture was taken around 1931 of students and some adults. The woman at the top-most position is the teacher, Lizzie Socks or Sacks. Genealogy research shows this name as having several spellings: Sachs, Sacks, Sox, and Socks. Pictured here are, from left to right, (first row) Tillie Holder, Mary Cramer, Mike Muneio, Martin Socks, Charles Zuelke, Jacob Rotarius, Martha Ploetz, Yetta Holder, unidentified, Tony or Joe Burk, Jim Muneio, Fred Spens, Oscar Hartsig, Martin Hall, Charlie Lorenz, Fred Schatzberg, Herman Hoffmann; (second row) Madaline Rotarius, Lillie Hoffmann, Susie Trombley, Addie Sacks, Emma Hoffmann, Ida Bunert, Charlie Horn, Rose Zuelke, William or Charlie Engle, Eddie Trombley, Louis Rausch, George Horn, and an unidentified boy. (WEA)

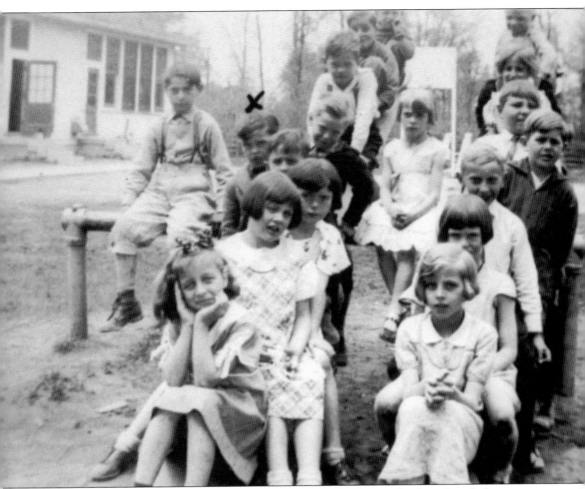

This is the eighth grade class of Bunert School, 1939. A family member has identified a young Albert Paglia with an "X." Warren Consolidated Schools was formed in 1941 and is considered one of the top kindergarten through 12th grade educational systems in Michigan. (WHS)

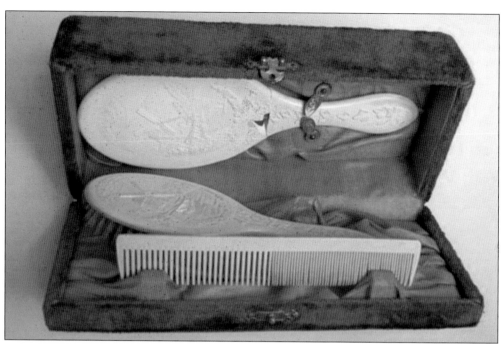

This decorative brush and comb set included a mirror and carved handles housed in a red velvet box lined in satin. It was presented to "our teacher from her scholars. She is always so good and kind to us" and lists the class contributors and amounts. Originally the school housed grades one through eight. This and the learning tools previously shown are on display at Bunert School. (Above, WEA; left, WHS)

A Christmas Present to our teacher from her scholars. She was always so good and kind to us.

Louisa B. Haussner	25¢
Bertha C. Haussner	10
Mary Haussner	10
Bella Verhoven	10
Christina Radloe	
Lizzie Maisel	15
George Maisel	10
Louisa Hedline	6
Anna Heussner	6
Mamma Metter	6
Lambert Metter	5
Emma Peters	3
John Seifferlein	
Emma Forster	20¢
Lizzie Braun	15
Gusta Distler	10
Gustav Cerbé	15

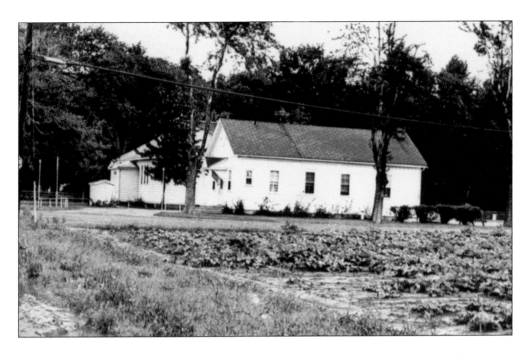

Above is Bunert School as it appeared in the 1980s. Next door to it is the Santa Maria Lodge. Warren Historical Society led the effort to save this piece of its heritage by moving it and restoring it to its 1910 condition. Below, the schoolhouse is ready to roll in one piece by Durst House Moving. Broken windows and overall disrepair are evident. Note the more modern elements added on to accommodate its residential use: a spotlight and mailbox with doorbell mechanism. (WHS)

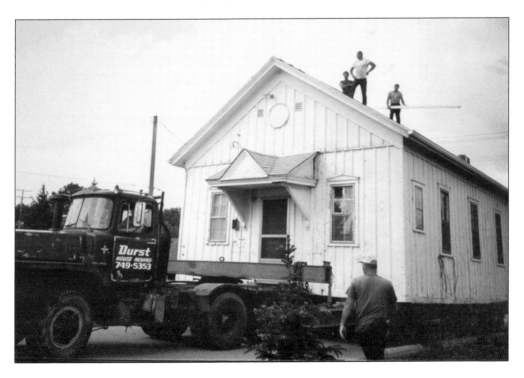

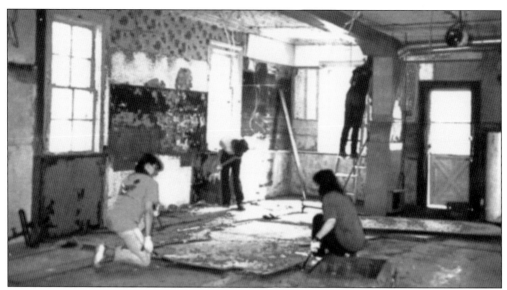

Members of the community are hard at work on the interior restoration. Wallpaper samples and artifacts are on display at the schoolhouse museum. According to the Historical Society, desks, artifacts, and other authentic ephemera were found and accessioned in or purchased to accurately depict the period interior. Cottage paneling was applied to the dado area of the wall. (WHS)

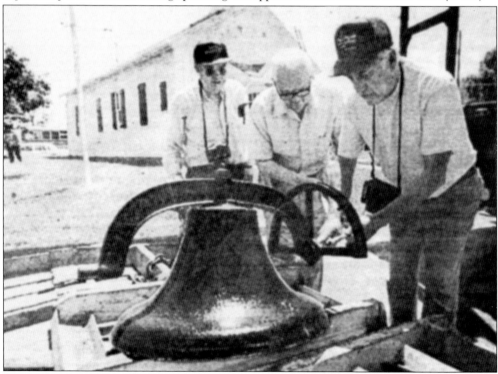

This newspaper photograph was taken by Patricia Beck on June 15, 1997 for a story about the school restoration. Herman Weier, left, and Robert Rinke, center, watch as John Salera prepares the bell for re-installation into its tower on top of the school. It now stands on the property of Warren Woods Tower High and is open to the public most Sundays and for special events. (WHS)

The West School, established in 1894, was at Ryan Road southeast of Creek Road, which became Chicago Road. It was originally a log cabin that was also used for the Methodist and Baptist services for a time. This one burned down in 1931 and was replaced with a third brick West School later that year. (WHS)

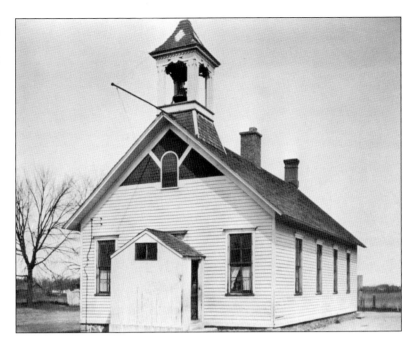

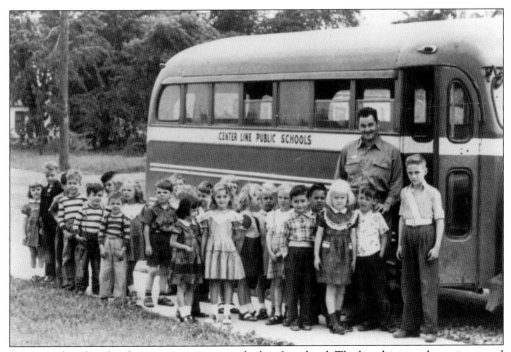

A group of grade-schoolers prepares to get on the bus for school. The bus driver and crossing guard pause for this picture before another day of supervising their safety. (WHS)

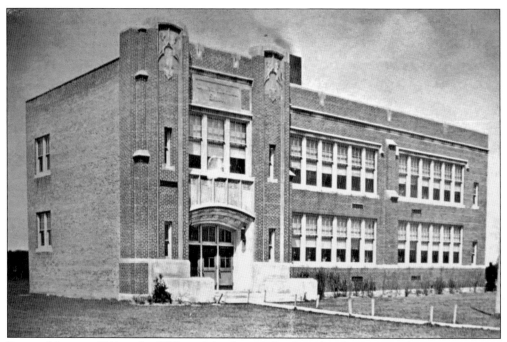

Pictured here in 1931 is the William Murthum School, with a later annex known as Victory High School. The school included elementary, middle, and high school grades in the 1930s. Its first graduating class had only three students. Warren High was built on property west of this site, and the current Warren Recreation Center added on to the school that faces Arden Road today. (WEA)

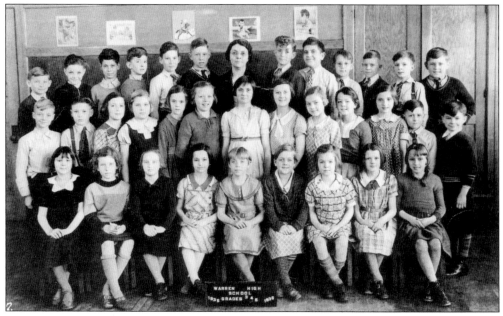

Shown here are grades three, four, and five of 1935 at Warren High School, previously Murthum School. With very small classes for most grades, in the early years lower grades were on the first floor and upper grades were on the second floor. (WHS)

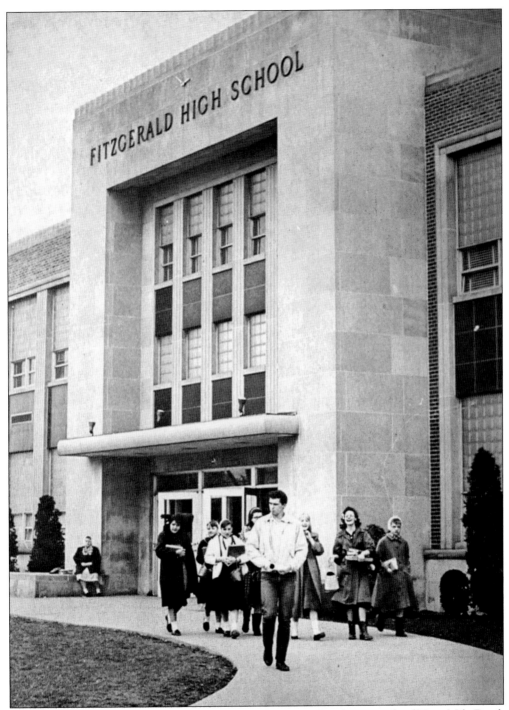

Fitzgerald High was built near the Mielke School on Ryan Road just north of Nine Mile Road. The popular speculation is that it was named after a school board member, as it was built about a decade before the assassination of Pres. John Fitzgerald Kennedy in 1963, which prompted municipal buildings across the country to rename themselves in honor of him. The John F. Kennedy Elementary School near Ten Mile and Hoover Roads is named in his honor. (WEA)

The south campus of Macomb County Community College (MCCC) is pictured here around 1965 at the intersection of Twelve Mile and Hayes Roads. The college began in 1953 with 22 teachers at Lincoln High School, until 1962, when land for three campuses was purchased. The Weier Family sold much of its acreage to the east of their farmhouse to the Board of Education for the construction of this community college. (WEA)

Here, MCCC art students draw the construction of the buildings that would become the south campus. The student population in 1964 was 5,300 and in 1969 classes cost $2 per credit. (MCCC)

Seven

TRANSPORTATION

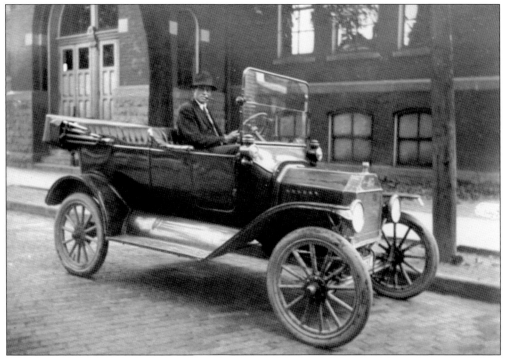

Looking very prosperous, one of the Weier men stopped just long enough to have this picture taken in his Model T, around 1920. Affordable cars signaled a greater independence for individuals, and expanded the radius of a person's ability to travel to and from work. (WEA)

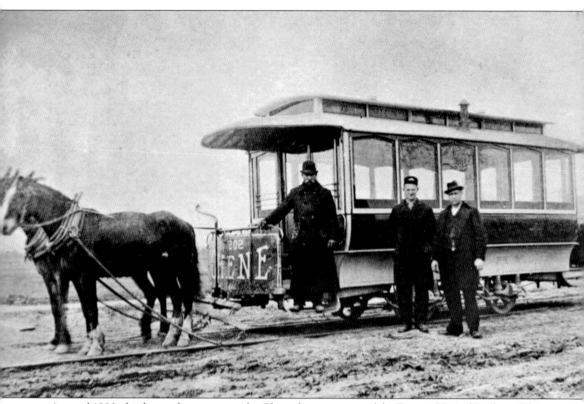

Around 1880, this horse-drawn car on the Chene line was part of the Detroit United Railway. This mode of public transportation was used since the days of the Civil War, but began to be replaced in 1892 when the electric trolleys came on the scene. An 1875 atlas map shows a stop for Warren Station at Ten Mile and State Roads at the Michigan Central Railroad (MCRR) tracks where Buechel's store was originally, and the earlier Kunrod's Corner. North in the village of Warren, the MCRR stop was called Oakwood Station, and just above that was Spinnings Station for the farm of that name just north of the township. (WHS)

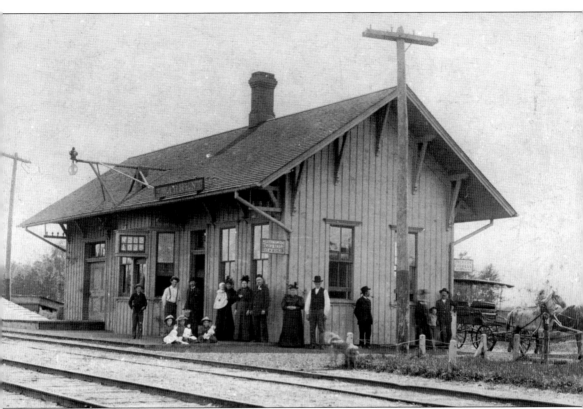

A panorama photograph shows people waiting for the train to pull in to Warren Station. The two signs at the front end of this board-and-batten structure advertise a Western Union Telegraph Office and American Express office. "N202 1035" is posted outside the station, indicating the next train and the time. (WHS)

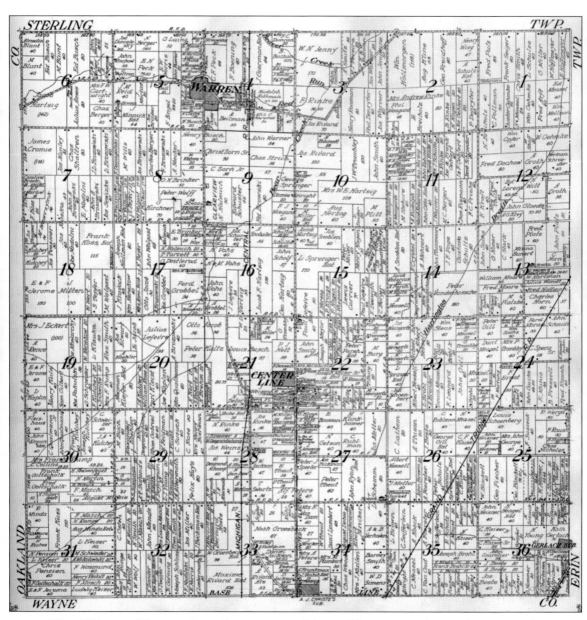

This 1916 map of the township indicates names of the neighboring townships and county on the outer edges, and routes for delivery (RFD) for the post office as dotted lines and arrows. At Van Dyke Avenue from Baseline to Ten Mile Road is a long white and black dash that indicates the Detroit United Electric Railway that loops around at the northeast corner of Ten Mile Road and Van Dyke Avenue. (Page 30 refers to this railway loop and the LeRoy blacksmith shop across the street.) (WHS)

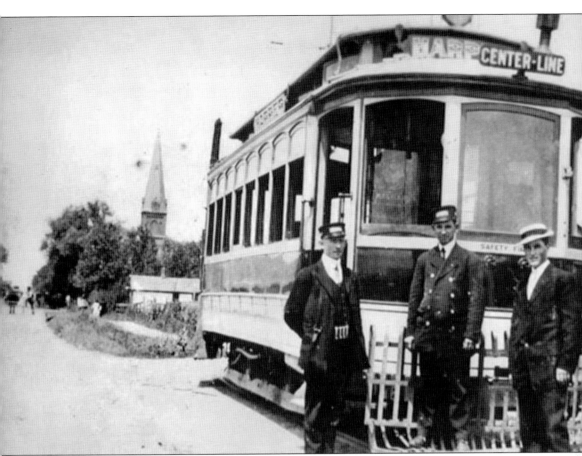

An innovation that swept the country and made it possible for people to conduct the day's business outside of their community was the Interurban. From 1901 to 1930, the Harper line shown here was widely used to connect Downtown Detroit with Warren Township. Its route looped at Van Dyke Avenue and Ten Mile Road. Note the "Safety First" label just under the center front window. The grate attached to each end of the streetcar was used for the purpose of literally scooping up people or animals that might fall in front of the moving car, to avoid running them over. This innovation came about because of the many complaints of such accidents. St. Clement church is in the background, so these men are standing at the terminal where the train turns around to head back to Detroit. (WHS)

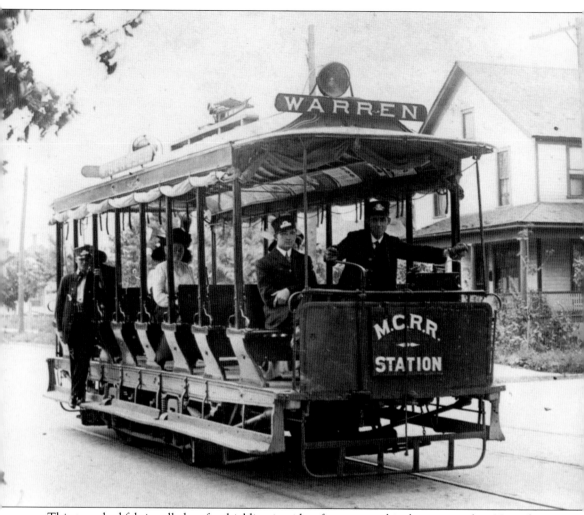

This tram had fabric rolled up for shielding its riders from sun and inclement weather. Note the updated, larger, and less elaborate safety grid on the end of the car. (MRB)

Model As proliferated, as shown again in this shot of one of the Weier family in Warren Village. On the far right edge of the photograph, Fred Lutz's blacksmithing and hardware store is just visible. (WEA)

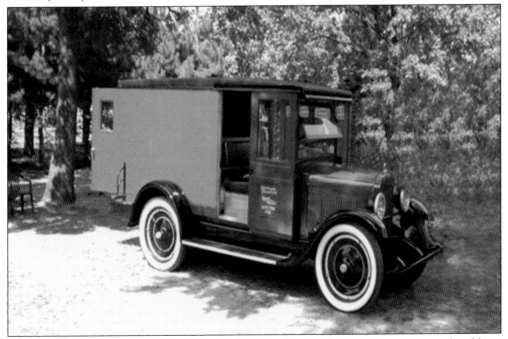

Business was probably pretty good after Prohibition for Goldie Girl Champagne to be able to afford this sharp delivery truck, complete with white-wall tires. The sign on the door boasts a "Home Brew / Bath Tub" and has the initials "JW" below that. (WEA)

A member of the Qualmann family remembers packing up the car in summer and vacationing at the Qualmann residence in Center Line. The Behrns-Qualmann farmhouse is the newest addition to the state register of historic properties. Since cars were not built with much storage space, goods were strapped on the outside, as shown. (WEA)

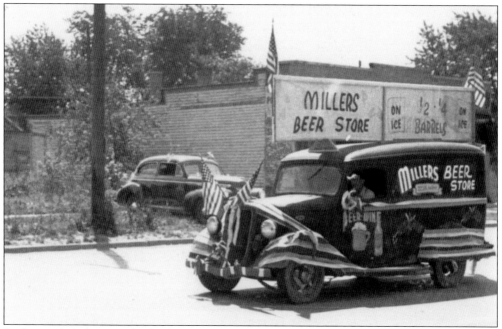

In this *c.* 1940 photograph, the delivery truck for Miller's Beer Store at 22235 Van Dyke Avenue is all done up for a Fourth of July parade down Van Dyke Avenue, just south of Nine Mile Road. By 1954, the Metropolitan Club yearbook listed Harold Godin as the new owner. (GF)

The Harper Line during business hours left from Harper in Detroit to Center Line. Once again, safety became an issue, as people would grab on to hitch a ride home. A *Detroit News* article even described people standing out in the cold and rain, letting the overcrowded cars pass them by until one came by that they would be able to board. (DTH)

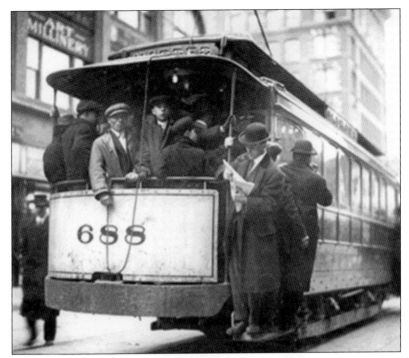

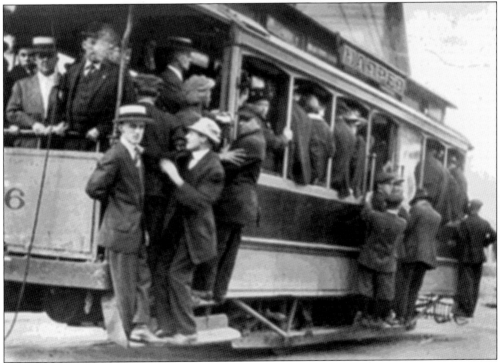

The car in this photograph leans precariously. This service was part of the Detroit Street Railway (DSR). The cost was 5¢ per person and in a *New York Times* article in February 1927, the DSR reported 12-month earnings of almost $600,000. That was extremely profitable for the time, and represented a lot of five-cent rides! (DTH)

School administration and transport continued to struggle with issues of safety in the 1950s. Here, officials and drivers of "Van Dyke," a popular name for the Center Line area around 1950, signed pledges for a safety drive conducted by the Fraternal Order of Eagles. Signers of the scroll, pictured here from left to right, were Lester Eagles (secretary of the Van Dyke area), John T. Kelsey, Frank

Zagalski (township justice of the peace), Raymond Decker (president of Eagles), Hildegarde Lowe (township clerk), Irvin R. Little (board of education president), Max Thompson (superintendant of schools), and bus drivers James Salsbury, Frank Halliard, William O'Connell, Charles Laury, Russell Clark, William Hackel, and Junior Ewen. (WHS)

School bus No. 2909 gave everyone a scare in the late 1940s when it was taking a group of students from Detroit into Warren Park. While crossing the bridge over Red Run Creek at Eckstein east of Mound Road, the old wooden structure gave way. The Schulte family lived on Eckstein and Dolores Schulte remembers that her father, Ed, helped to get the children safely off the bus. Footbridges and vehicle bridges have been proposed over the years east and west of Mound Road, but this bridge has never been replaced. Warren Park was a lively destination for employee and holiday picnics, and was busy most weekends with its baseball diamonds, a hill for sledding, fire pits, and something for everyone. (WHS)

Eight

COMMUNITY

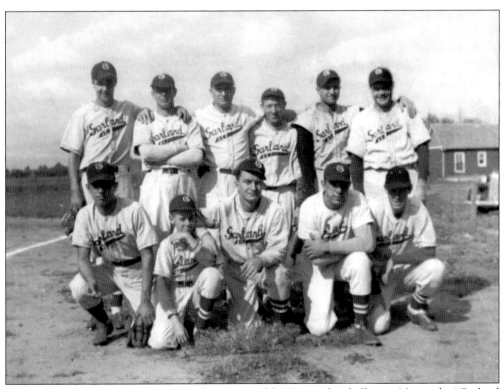

William Romano is front and center in this picture of the Warren baseball team. Notice the "Garland AC" on team jerseys. Garland was one of the many names given to the Center Line area in the first half of the 20th century. Another team picture taken later showed many of the same players with jerseys that had a "WAC" logo on the pockets, for the Warren Athletic Club. (WHS)

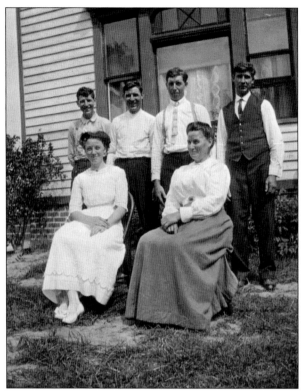

Pictured here is the Steffens family around the 1920s. From left to right are (first row) Laura and Grandmother Mary S. Steffens (second row) Ernest, Emil, Julius, and Paul. Later, a newspaper photographed "Ernie" Steffens with a 1935 fire truck, which was then the Warren fire department's newest addition. Brother Emil, shown below c. 1930 at the gas station at Mound Road and Beebe Avenue, helped park cars for church services. (WHS)

Who says nothing is free? After "The Big Flood" of spring 1947, the already marshy land of Warren left Louie Benincasa's land flooded at 5030 Chicago Road. He advertised a free dumping zone for dirt and stone. (WHS)

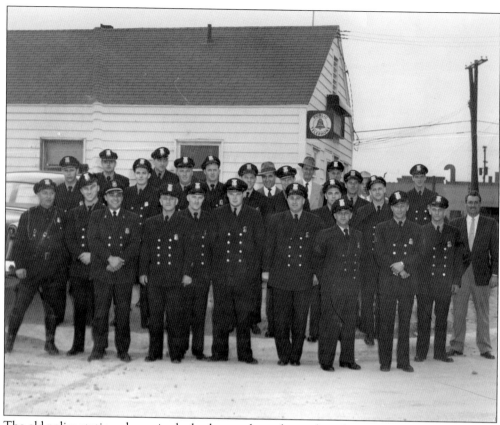

The old police station, shown in the background, was located on the northwest corner of Dodge and Memphis Avenues. Shown from left to right in this 1952 photograph are, (first row) Albert Carrier, Clyde Mooneyham, Vincent Romano, Michael Helmlinger, Vincent Wojciechowski, Robert Wilson, Raymond Uritescu, Frederick Maletta, Howard Galeener, Alvin Akers, and Gordon Rabideau; (second row) Irvin Little Jr., John Spence, Ronald Pattison, Richard Fewer, Leonard Sikorski, Robt. Galvin, Anthony Lipski, Walter O'Bee, John Connors, Anthony Winters, Charlie Rains, Irvan Welch, Alex Lupan, Gordon Tullock, Williamm Hawes, Louis Buckner. (WHS)

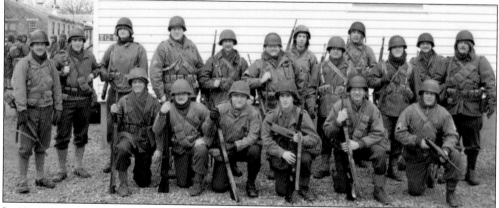

In 1944, Company L of the 109th Infantry, 28th Division of Center Line, marches off to help win World War II. In addition to sending its citizens to war, the community's Chrysler tank arsenal had a pivotal role in bringing the war to an end in 1945. (WEA)

Clement Grobbel and Marcella Peters are shown here in their wedding picture. They had eight children, and Clement later remarried after Marcella's death in 1937. In his later life, he rang the bells at St. Clement church, which were heard three times a day from 1880 until the church was town down to make way for the current edifice. (GF)

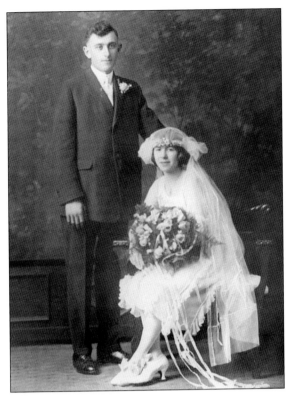

Clement Grobbel was the first appointed police chief for Center Line when it incorporated in 1936. He was active in the Metropolitan Club, Goodfellows, Knights of Columbus, Polar Bears, American Legion, and was a veteran of World War I. He was born in 1895 to Anthony and Mary Minnick Grobbel at Eleven Mile and Mound Roads, and had four siblings: Edward, Leo, Marie, and Agnes. The Vohs farm neighbored theirs. He proudly rang the church bells of the old St. Clement church until it was torn down in the late 1960s. This picture was taken June 6, 1965, shortly before his 70th birthday. (GF)

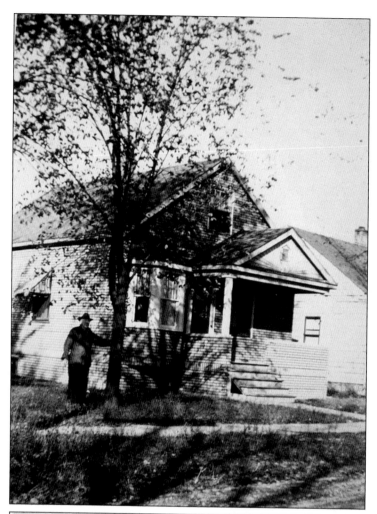

In the 1940s, Thurston Stewart found the object shown below while digging the foundation for his house on Lillian Street. This ground and polished piece of granite is believed to date back 3,000 years, belonging to a different people than the known Native American tribes of the area, who mined copper from the upper peninsula and had Mexican roots. (WEA)

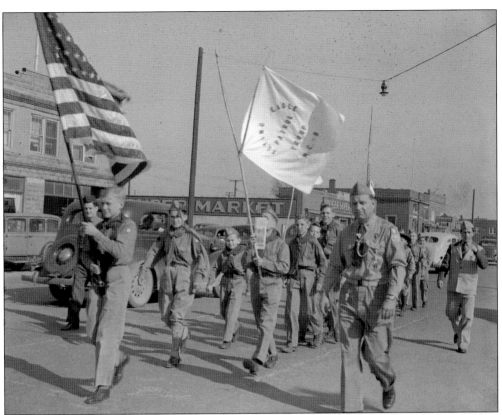

In 1945, Warren–Center Line members of Troop No. 8 from the Flying Eagle Patrol had a Sunday ritual of marching to communion from troop headquarters to St. Clement and back. Warren had a 60-year history of scouts. At right is the Boy Scout Oath, Scout Law, and Cub Scout Promise. (GF)

"ON MY HONOR I WILL DO MY BEST, TO DO MY DUTY TO GOD AND MY COUNTRY AND TO OBEY THE SCOUT LAW. * TO HELP OTHER PEOPLE AT ALL TIMES * TO KEEP MYSELF PHYSICALLY STRONG, MENTALLY AWAKE AND MORALLY STRAIGHT. — The Scout Oath

A SCOUT IS TRUSTWORTHY, LOYAL, HELPFUL, FRIENDLY, COURTEOUS, KIND, OBEDIENT, CHEERFUL, THRIFTY, BRAVE, CLEAN, REVERENT. —The Scout Law

I PROMISE TO DO MY BEST TO DO MY DUTY TO GOD AND MY COUNTRY, TO BE SQUARE AND TO OBEY THE LAW OF THE PACK. — The Cub Scout Promise

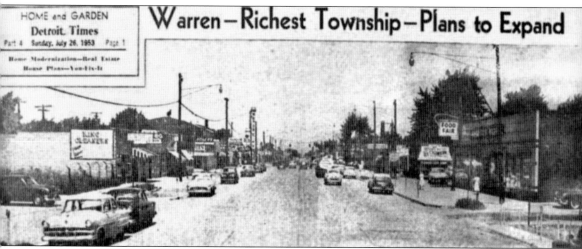

Warren–Richest Township–Plans to Expand

Main Street in Warren was actually still considered Nine Mile Road and Van Dyke Avenue in this picture looking north. A *Detroit Times* article on July 26, 1953 said the township was the self-proclaimed richest in the country with its large industrial companies. The rich Midwestern industrial belt in general, and the automotive industry in Warren in particular, made this assertion possible. Part of the city's expansion plans included widening the Van Dyke corridor. (WEA)

Connell's Texaco Service Station in Center Line sponsored this comic car, shown doing a wheelie while entertaining the crowd during a 1950s parade in thriving Warren Township. The car was built by Clement Grobbel's sons Vincent and Robert and became a fixture in local parades. The sponsor was Spence Connell's Texaco Service Station at Ritter Street and Van Dyke Avenue, which became a Kayo gas station after Connell moved his business to Stephens Road and Van Dyke Avenue. The Detroit Shriners later bought the car and it is still used by their Keystone Kops clown unit. (GF)

In Warren Village, a float at Chicago and Mound Roads sponsored by Unity Service of Warren carries the banner "Leaders of Tomorrow" as it makes its way across the intersection. The C. F. Peck store is in the background, and by this time was run by Marion Peck Halmich and Norman Halmich. The old post office stop became a barbershop at this time, which is still open for business, and Village Bakery is next to that. The Village Bakery building stands today, while Peck's was replaced by the Halmich professional building when the road was widened in the 1940s. (WHS)

Students cross under the old Mobilgas sign at Van Dyke Avenue and Gronow Street after school, in a slice of life from around 1950. They may have come from the lunch counter at Van's Pharmacy behind them, a popular destination offering competition to Homer Hazelton's Center Line Drugs. Hazelton was a beloved member of the community and was often seen playing the organ in his store. (WEA)

A long-forgotten bet had a public payoff between the good-natured rivalry of Tony's Place and Bea's Grill, around the 1950s. A similar payoff was captured between Homer Hazelton and mayor Arthur Miller in which Homer was put into a wheelbarrow, pushed by the mayor. (WEA)

Eugene Mandziuk and his sister Irene cross Ryan Road at Martin Road with the family dog. Their mother is coming down the road in her maroon Ford. Close examination shows the dust kicked up by her car. (WHS)

Christmas 1949 shows something very popular in the community at that time: the console television set. So intrigued with this new invention, people would stand outside hardware stores watching the televisions in the window until they were able to afford one for their home. The picture would have been only black and white at that time. Anna Sewell's classic novel *Black Beauty* leans against the television. The cat may have been a new addition that day as well. (WEA)

ROLAND J. RINKE

Rinke Pontiac-Cadillac Co.
25420 Van Dyke Ave.
Center Line,
Michigan

Je-6-6260 Sl-7-0767

A page from the Fitzgerald High yearbook shows a lively advertisement for this Chevy dealership. The address for the Rinke land purchased long ago with Michael Smith, north of St. Clement's, is 27100 Van Dyke Avenue and is Rinke Toyota today. In a 1945 phone book for the area, this dealership had an advertisement on the cover with a different phone number, but still using the Slocum exchange. (WEA)

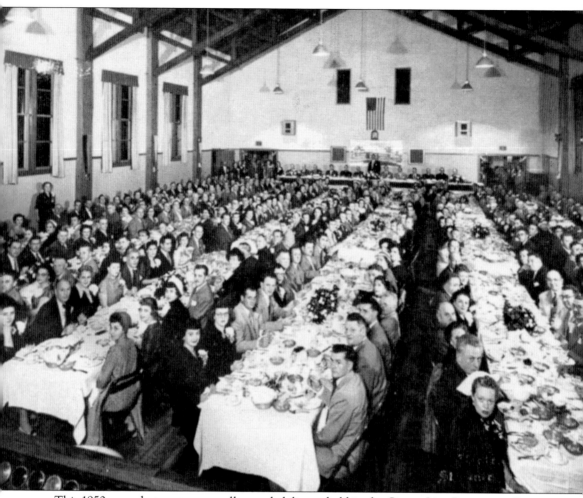

This 1950s snapshot captures a well-attended dinner held in the Center Line Recreation Center on the west side of Van Dyke Avenue just north of Ten Mile Road. The south wing of the building held the library. Tom Pounder ran the center, which offered activities for all ages. This was originally built as a USO in 1941, and after the war it became the city's recreation center. It was torn down during the urban renewal program in the late 1960s. (WHS)

Michigan governor G. "Soapy" Williams (1949–1961) is captured here visiting the city with Ms. Lowe, who was known to be very visible at community events during her tenure as a member of the city council. A Michigan native, Governor Williams was from the family of Mennen toiletries fame, thus earning his nickname "Soapy." (WHS)

John F. Kennedy had a campaign stop in Warren, delivering a speech at the Tech Plaza at Twelve Mile Road and Van Dyke Avenue. Note the J. C. Penney store in the background, which later became a Wal-Mart. Warren City Council member John A. Rinke is visible behind Kennedy's shoulder, and it looks as if council member Hildegarde Lowe might be asking Kennedy to autograph her copy of his Pulitzer Prize-winning book, *Profiles In Courage*. (WHS)